IMAGES
of America

SAN FRANCISCO'S
FILLMORE DISTRICT

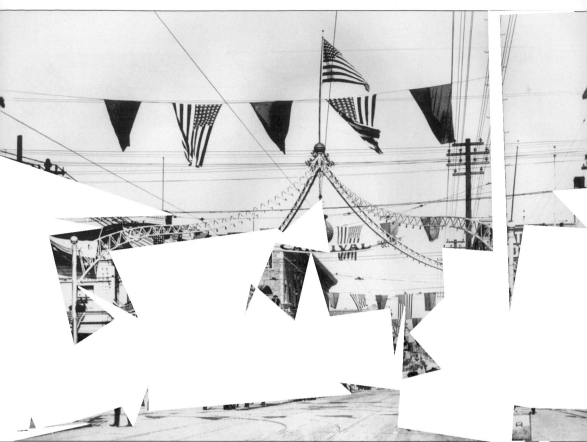

This September 1913 photo of the Fillmore Street Carnival was taken from the intersection of Fillmore and O'Farrell, looking north toward Geary Street. (Courtesy of Jerry Flamm.)

IMAGES
of America

SAN FRANCISCO'S
FILLMORE DISTRICT

Robert F. Oaks
Foreword by Christopher Caen

ARCADIA

Published by Arcadia Publishing
Charleston SC, Chicago IL, Portsmouth NH, San Francisco CA

Printed in Great Britain

Library of Congress Catalog Card Number: 2005922450

For all general information contact Arcadia Publishing at:
Telephone 843-853-2070
Fax 843-853-0044
E-mail sales@arcadiapublishing.com
For customer service and orders:
Toll-Free 1-888-313-2665

Visit us on the internet at http://www.arcadiapublishing.com

ABOUT THE AUTHOR

Robert F. Oaks is a fifth-generation Californian and a longtime resident of San Francisco. He received his B.A. degree from Stanford University and a Ph.D. from the University of Southern California, both in history. After several years of teaching at the university level, he joined the corporate world for more than 20 years before retiring in 2001. He now spends much of his time researching and writing history, emphasizing the chronicles of Hawaii and San Francisco. His *Hawaii: A History of the Big Island* appeared in 2003 in Arcadia Publication's "Making of America" series. He has also published several scholarly articles on San Francisco in the professional journals of the California Historical Society and the San Francisco Museum and Historical Society.

CONTENTS

FOREWORD

If America is the great melting pot, then the Fillmore District is San Francisco's very own cultural Cuisinart. Spared the ravages of the Great Earthquake, the area has maintained its diversity through depressions, wars, and redevelopment. Many claim that San Francisco is really a town masquerading as a city. If this is true, then the Fillmore is a village masquerading as a district.

Who are the people that make up this place? White, black, Asian, poor, middle-class; you name it, they have lived here. And unlike the more known enclaves like Chinatown or North Beach, the Fillmore has a tendency to live quietly within itself. Indeed, you have to search a map of the city to find Fillmore, a slender artery that starts at the Bay, rolls through the landfill that is the Marina District, up past the elegant houses that make up Pacific Heights and then down into the Fillmore District itself, picking up speed as it races pasts stores and restaurants from dozens of different cultures before hitting the heart of the area at the bottom of the hill.

Walking through the Fillmore is literally walking through the history of San Francisco. Here is where the tents were put up after the earthquake destroyed almost everything east of Van Ness Avenue. There is where Bop City and the other great jazz establishments were. And the Japanese of the Fillmore District carry the scarred history of their time in our country. Look down as you walk the sidewalks and you will see bricks inscribed with the names of all the great musicians that have played in the area. Look up and you can still imagine the graceful metal arches that used to loft over the major intersections.

I grew up at the top of the Fillmore hill, and then spent the rest of my youth moving around and living in different areas of the city as I progressed from family to college to work. When it came time to start a family, there was no question I would wind up back in the Fillmore District. After all, as any European can tell you, if you grow up in a village you never really leave it.

—Christopher Caen

ACKNOWLEDGMENTS

Many individuals took an interest in this project and helped me both in learning about the history of the neighborhood and in procuring the photographs that are the heart of this book. My sincere thanks to Marie Browning of the San Francisco Redevelopment Agency Archives, Jerry Flamm, John Freeman, Greg Gaar, Susan Goldstein of the San Francisco Public Library's History Room, Renee Renouf Hall, Louise Hanford, Johnnie Ingram, Steve Nakajo of Kimochi Inc., Caroline Ocampo of the Fillmore Jazz Preservation District Office, mapmaker Ben Pease, my editor John Poultney of Arcadia Publications, Linda Jones Suzuki of the San Francisco Public Library's Western Addition Branch, and Elizabeth Pepin and Lewis Watts, who have recently completed a book about music in the Fillmore.

INTRODUCTION

San Francisco's "Fillmore District" is as much a state of mind as it is a geographic area. Few if any neighborhoods went through so many transitions throughout the 20th century—some positive, some negative—that forced residents to reinvent the neighborhood time after time. Geographically, the Fillmore means different things to different people. A subset of the larger area called the Western Addition, Fillmore Street itself is the focus of this book, from about Fulton Street on the South to Bush Street on the North, and several blocks to both the east and west, including Japantown. This area is sometimes referred to as the "lower Fillmore."

From a sleepy "suburb" in the late 19th century, with streets that looked much more permanent on early maps than they did in reality, the neighborhood was transformed overnight by the 1906 Earthquake and Fire. Fillmore Street itself from its neighborhood's beginnings had many businesses that primarily supported its residents, but before 1906 there was little to attract outsiders to the area. Then, with downtown destroyed by quake and fire, Fillmore Street suddenly became a "new Market Street," with temporary quarters for businesses, theaters, and government agencies.

Fillmore Street merchants hoped the neighborhood would remain a permanent magnet for shoppers. They installed arches and lights to provide "glitter" and advertised the benefits of the area. They even promoted a tunnel through the Fillmore Street hill to make it easier for people from North Beach to get to their shops. Others argued for a Steiner Street tunnel, but Union Square and Market Street merchants had more political clout and the tunnel instead went to Stockton Street. The neighborhood did remain a center for entertainment—amusement parks, vaudeville, movies, and ultimately jazz and rock music—but for the most part shops reverted to serving the neighborhood.

The earthquake changed more than just the mercantile aspect of the Fillmore. It also changed the racial and cultural makeup. Before 1906, it was largely a white, middle-class district with a significant Jewish population, some immigrants, and a few African Americans. Afterwards, there was an influx of Japanese, who had previously congregated near Chinatown and in the South of Market South Park neighborhood. When both areas were destroyed, the Japanese began moving in an area that would soon be called Japantown, or Nihonmachi.

Other groups crowded into the Fillmore as well, and buildings that had been single-family houses were soon converted into multiple dwellings and rooming houses to support the growing population. One long-term result is that the Fillmore remained a relatively cheap, if crowded, place to live in the city.

These various ethnic and cultural groups lived in relative harmony, without the legal segregation that existed in many other cities throughout the country. Kosher delis and Japanese restaurants, as well as ordinary diners and cafes existed side by side throughout the 1920s and 1930s.

The next big upheaval came with World War II. Within days after Pearl Harbor, the federal government concluded that it was necessary to evacuate all persons of Japanese ancestry (citizen and non-citizen alike) from San Francisco and other West Coast cities. Fearing unsubstantiated plots and support for Japan, the government forced the Japanese to relocate to hastily constructed camps scattered throughout the country, but primarily in western deserts. Most San Franciscans ended up in a camp in Topaz, Utah.

At a time when the Japanese were forcibly moved out, many African Americans, seeking lucrative wartime jobs, migrated to California from throughout the country. Those who came to

San Francisco found available living accommodations in the houses, flats, and boardinghouses recently vacated by the Japanese.

Before long, the new residents brought jazz to the neighborhood, with new nightclubs in newly deserted buildings. After the war, the Fillmore continued to be one of the country's premier locations for jazz, often referred to as "Harlem West." Throughout the 1940s, 1950s, and into the 1960s, the Fillmore attracted crowds to the neighborhood. Then, in the later 1960s and 1970s, as jazz declined somewhat in popularity, rock music moved into major auditoriums and continued to attract large—if somewhat different—crowds to the Fillmore.

Another transformation of the neighborhood came with the decades of urban redevelopment that destroyed many buildings, and disrupted more than a few lives, in an attempt to clear slums, reduce crime, and improve housing for poor and middle-class residents. The goals were lofty, but the reality often painful. Much of the old neighborhood, especially south of Geary Boulevard, was literally bulldozed away.

Residents were forced to move, most of them poor, and though there were promises that they could some day move back, the reality was quite different. Indeed, the population of the entire Western Addition steadily declined from 1950 to 1980. African Americans who moved in during World War II now had to leave. Japanese Americans, who began returning after the war, were again forced to relocate. Fifteen hundred residents and 60 businesses in Japantown alone were displaced.

Ultimately, new housing was indeed built, including several high-rise apartments, but the character of the neighborhood had been changed. Parks, fountains, and plazas now exist in areas that formerly contained crowded dwellings and decaying businesses.

One

THE EARLY YEARS

In the 1850s and 1860s, the new Western Addition to the city consisted of little more than sand dunes and a few dwellings of dubious quality on a trail somewhat optimistically called Bush Street. Beginning in the 1870s, however, real estate developers began to build Victorian tract houses, though the pace was slow and the area remained fairly "rural" for much of the rest of the 19th century.

By 1895, the *San Francisco Examiner*, writing about the city's "suburbs," praised the growth in the Western Addition. The recent opening of a cross-town line of the Market Street Railway spurred the growth of retail businesses on Fillmore Street, recently paved with "bituminous rock."

The 1906 earthquake and fire changed everything. Though there was earthquake damage, it was relatively light compared to other areas of the city, and the fire spared the area completely. The result would be a post-quake boom as businesses and residents moved, at least temporarily, into the Fillmore.

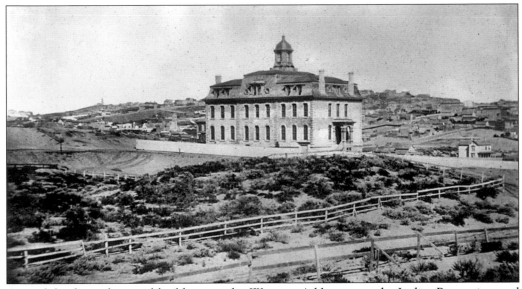

One of the first substantial buildings in the Western Addition was the Ladies Protection and Relief Society, shown here in 1865. The building, at the "intersection" of Franklin and Geary Streets, was completed the previous year at a cost of $23,000. (Courtesy of the author.)

9

This 1882 photo, taken at the corner of Laguna and Fulton Streets, shows cable being hauled to a new McAllister Street cable house in order to bring transportation to the Fillmore. (Courtesy of the author.)

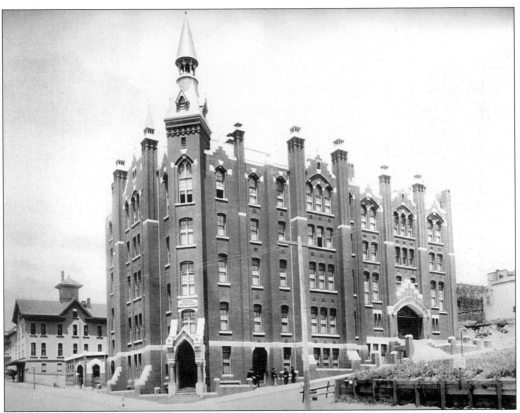

This impressive building, constructed in 1882 at Webster and Sacramento Streets, housed the Cooper Medical College. Several years later the college merged with Stanford University and became the Stanford Medical School. (Courtesy of the author.)

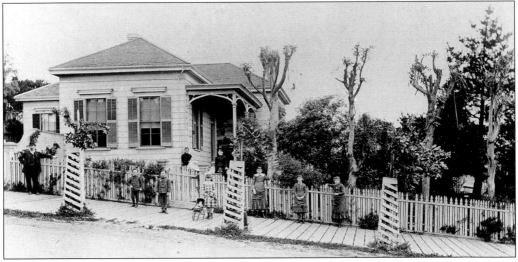

The rural nature of the Fillmore is reflected in this 1883 photo of the Spottiswood House at 2948 Ellis Street, near Webster. Note the wooden sidewalk and unpaved street. (Courtesy of the San Francisco History Center, San Francisco Public Library.)

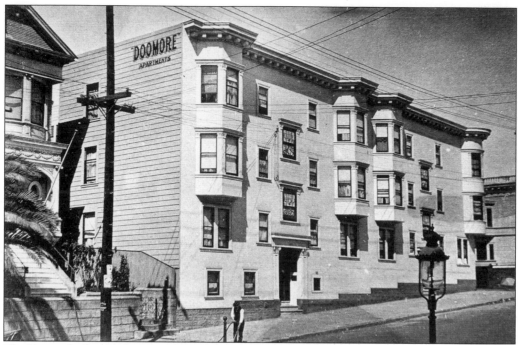

The Doomore Apartments were on Broderick Street, near Bush. Probably dating from the early 1900s, this photo shows paved streets and sidewalks, as well as a hitching post and gas street lamp. (Courtesy of the San Francisco History Center, San Francisco Public Library.)

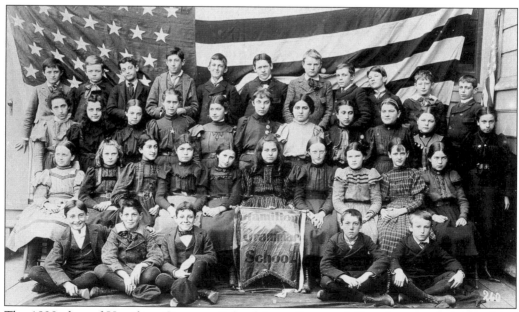

The 1898 class of Hamilton Grammar School (near Scott and Geary) was exclusively white. The racial mix of schools in the Fillmore District would change dramatically in coming years. (Courtesy of the San Francisco History Center, San Francisco Public Library.)

The Turk, Eddy, and Divisidero Street line of the Market Street Railway promoted the growth of the Fillmore. This early 20th-century photo shows the then common spelling of "Devisadero." (Courtesy of the author.)

This view of the Fillmore and Western Addition is from Alamo Square in the early 1900s (before the earthquake). The dome of the new (and soon to be destroyed) city hall is at the far right. The Call Building on Market Street is in the center of the picture. (Courtesy of the author.)

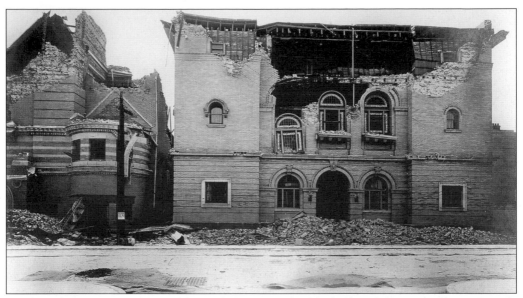

The brand new Congregation Beth Israel Synagogue (on the left) and the Scottish Rite Temple on Geary near Fillmore were both heavily damaged. The estimated $75,000 that it would take to clear debris and rebuild the synagogue was an impossible sum for the congregation of 350 families, many of them recent immigrants from Eastern Europe. With help from the much richer Temple Emanu-El, Beth Israel would be rebuilt and continue to serve the neighborhood for several decades. Vacant by the 1970s, it would become the People's Temple presided over by Rev. Jim Jones. (Courtesy of the San Francisco History Center, San Francisco Public Library.)

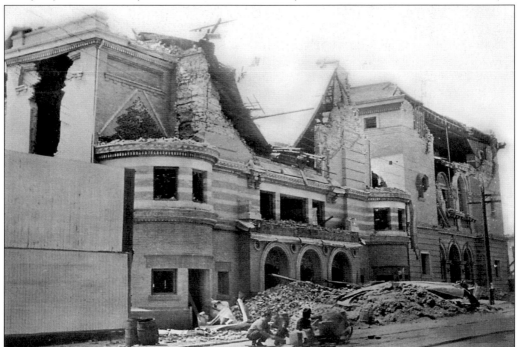

This image shows another view of the damage to Beth Israel and Scottish Rite Temple. (Courtesy of the author.)

The United Railroad car barn at Fillmore and Turk did not suffer major damage, but note the temporary braces. (Courtesy of the California Historical Society, FN-31101.)

Hamilton Junior High School (formerly Hamilton Grammar School) on Geary near Scott sustained no serious damage from the earthquake. For several months after, this building housed the city's municipal courts. Built in 1875, the structure was torn down in 1930. (Courtesy of Jerry Flamm.)

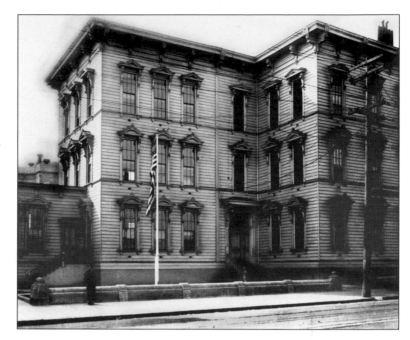

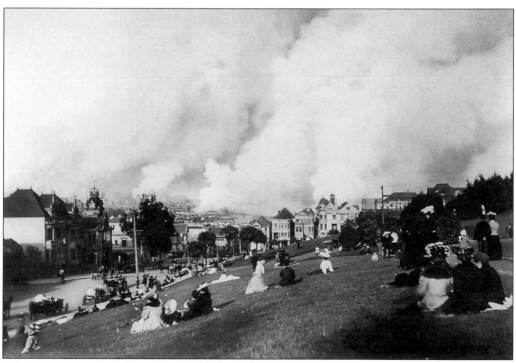

Fillmore residents and others watched the burning city from Alamo Square, undoubtedly praying that the fires would stop before reaching their neighborhood. (Courtesy of the author.)

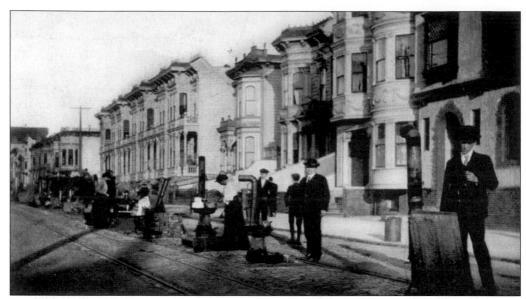

Residents throughout the city moved their stoves to the street and cooked outside in order to guard against new fires. When in public, San Franciscans dressed properly despite such temporary inconveniences. (Courtesy of John Freeman.)

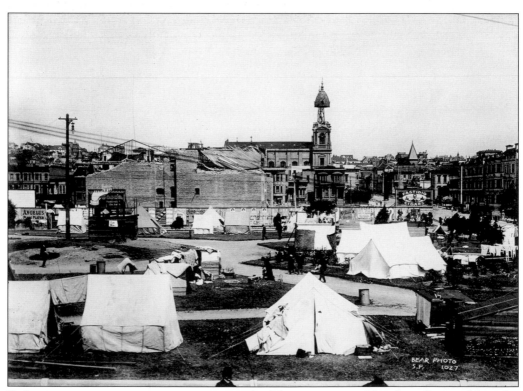

Refugee camps were set up in most city parks. This one was in Hamilton Square. Note the damaged buildings, including St. Dominic's Church, in the background. (Courtesy of the California Historical Society, GN-1013.)

This view looks up Hayes Street from Octavia and shows rubble from damaged buildings piled in the street. (Courtesy of John Freeman.)

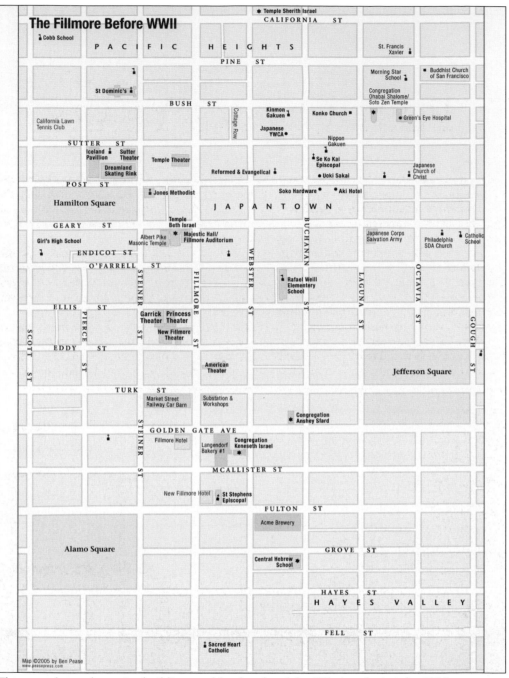

The Fillmore Before WWII

This map shows the major buildings and landmarks of the Fillmore during the 1930s.

Two
POST-QUAKE YEARS

The years immediately following the disastrous 1906 earthquake and fire brought many changes to the Fillmore. Though the area saw some major quake damage, it was left untouched by the fire. Primarily a quiet residential neighborhood before 1906, the Fillmore quickly became one of the city's major commercial areas as businesses set up temporary locations, sometimes in private homes, while downtown underwent reconstruction.

There were also population and demographic changes. The Fillmore had a substantial Jewish population before the earthquake. Now, large numbers of Japanese also moved in after seeing their previous neighborhoods—especially parts of Chinatown and South of Market's South Park—destroyed. The increase in population meant that many single-family houses were turned into boardinghouses and multiple residences.

Many of the larger businesses moved out within a few years, despite efforts of merchants to transform Fillmore Street into a permanent major business district. Smaller businesses catering largely to neighborhood residents continued to prosper, but Fillmore Street would never replace the rebuilt Union Square and Market Street locations as the city's primary shopping district.

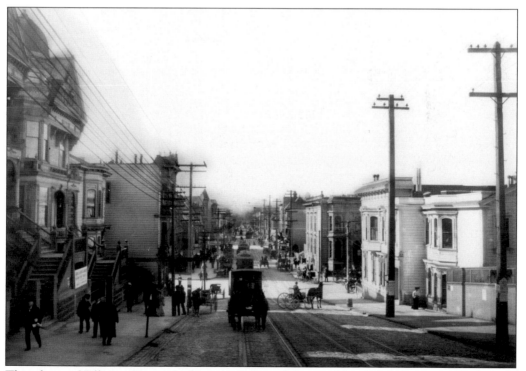

This photo of Fillmore Street, looking north from Fulton in May 1906, shows a still relatively quiet scene. (Courtesy of the author.)

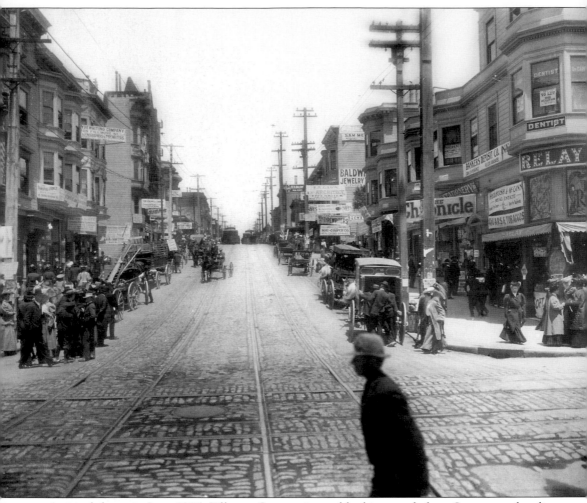

A month later, in June 1906, Fillmore Street, pictured looking north from Sutter, was bustling with businesses that had relocated after the earthquake and fire. Note the temporary signs on the buildings. (Courtesy of the author.)

This photo of Golden Gate Avenue near Webster shows that many businesses set up shop in private residences. (Courtesy of John Freeman.)

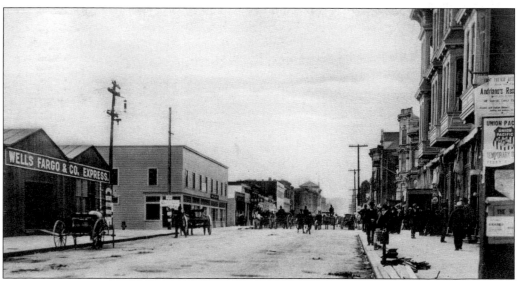

This view is of Golden Gate Avenue near Franklin in December 1906. Note the sign for temporary offices of Union Pacific Railroad. (Courtesy of John Freeman.)

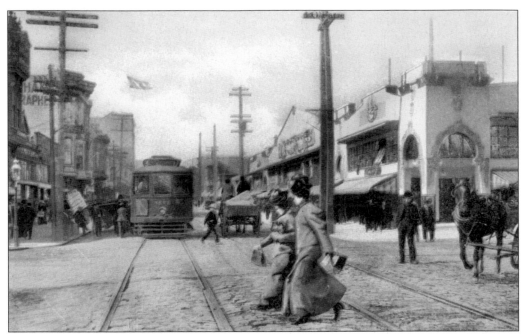

This postcard drawing shows Fillmore Street, looking north from O'Farrell, *c.* 1907. (Courtesy of John Freeman.)

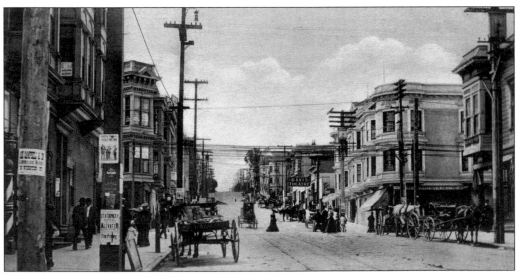

This image shows Fillmore Street looking west from McAllister, *c.* 1907 (the theater on the right). The Davis Theatre opened in June 1906 and remained in business for only about a year, until downtown theaters were rebuilt. (Courtesy of John Freeman.)

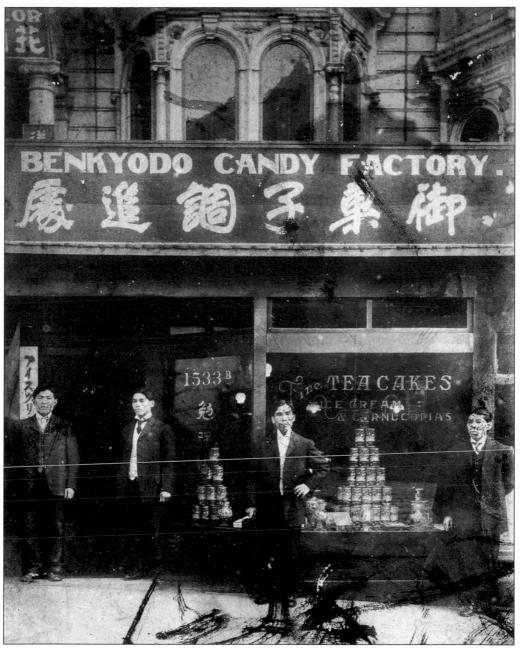

The Benkyodo Candy Factory stood for many years at 1533 Geary Street, shown in this 1906 photo. Relocated in the 1970s due to redevelopment, it continues to do business in the 21st century from a new location at 1747 Buchanan Street. (Courtesy of the San Francisco History Center, San Francisco Public Library.)

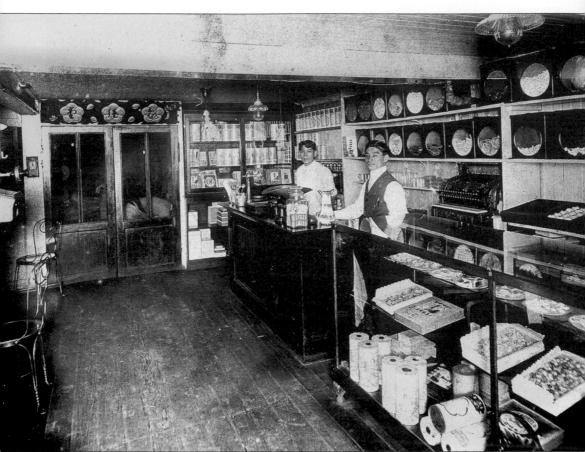

This interior view of the Benkyodo Candy Factory shows some of the goodies that allowed it to remain in business for a century. (Courtesy of the San Francisco History Center, San Francisco Public Library.)

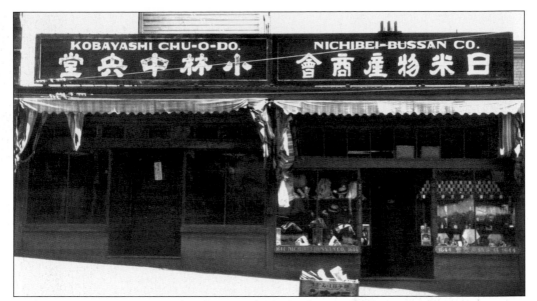

Nichi Bei-Busssan Company has been in business for over 100 years, selling to Japanese immigrants and residents. Until the 1906 earthquake, the store was in Chinatown. In 1907, the store moved to the location shown here at 1644 Gough, and then in the 1920s to a bigger store at Post and Buchanan. The owners closed the San Francisco store in 1997, but continue to operate a similar one in San Jose. (Courtesy of the author.)

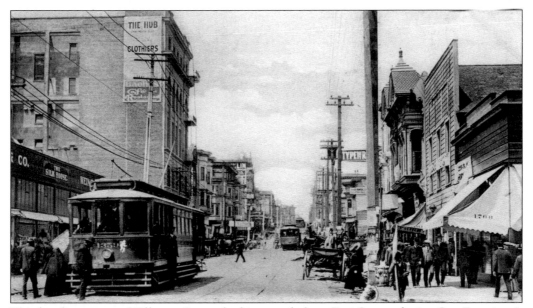

This bustling scene of Fillmore Street, looking north from Post Street, depicts San Francisco's "new business center," as 1907 boosters referred to it. (Courtesy of John Freeman.)

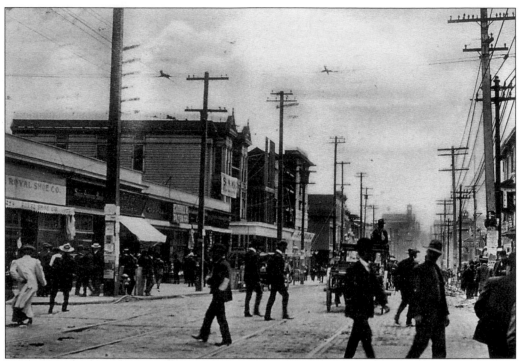

This *c.* 1906 photo shows Fillmore Street, looking south from O'Farrell, with the tower of Sacred Heart Church in the distance on top of the hill. (Courtesy of John Freeman.)

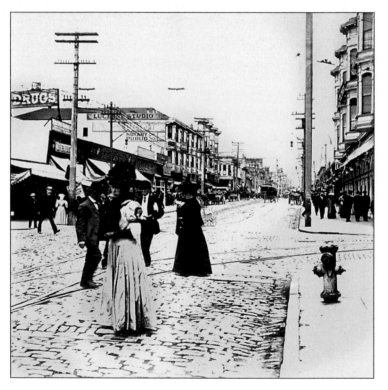

This photo of the intersection of Fillmore and Ellis was taken August 23, 1907. While difficult to make out in the photo, the venerable firm of Roos Brothers had opened their store halfway down the block on the right. Schoenfeld and Brothers Furnishings, on the left at 1679 Ellis, was in the midst of a bankruptcy sale. (Courtesy of the author.)

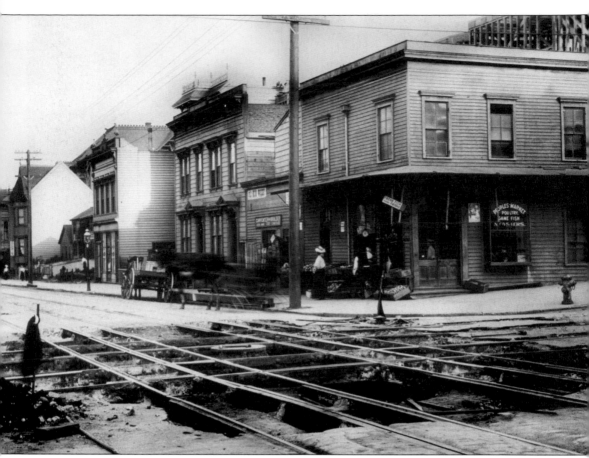

Restoring public transportation after the earthquake was crucial for recovery. By October 1906 work was nearly complete restoring the Geary and Divisidero Streets Line. (Courtesy of the author.)

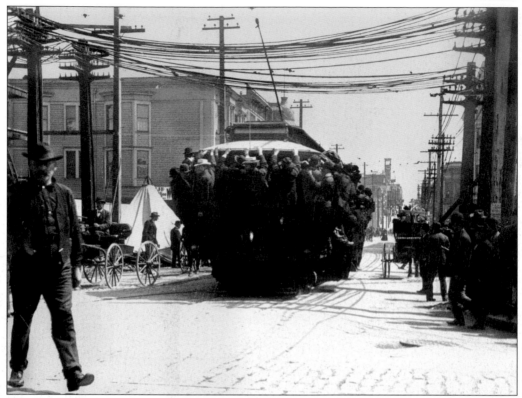

The first street car to leave the barn after the earthquake was obviously popular on Fillmore Street. (Courtesy of the author.)

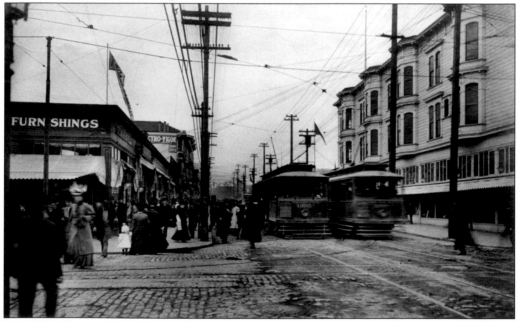

By 1907, the street cars were back in service for the crowds of shoppers. (Courtesy of the author.)

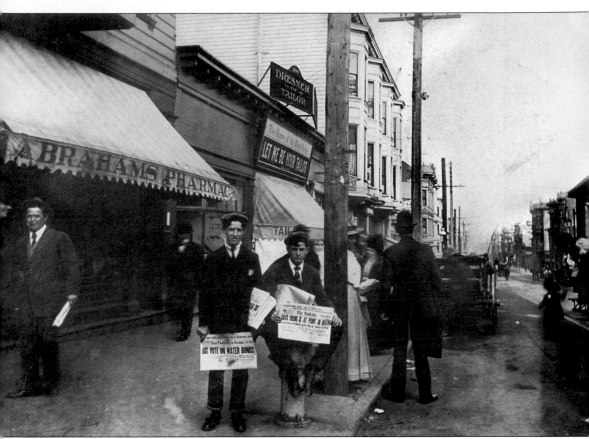

Abraham's Pharmacy and Dresner Tailors ("Let Me Be Your Tailor") were at 1198 and 1188 McAllister at Fillmore when this 1909 picture was taken. (Courtesy of the author.)

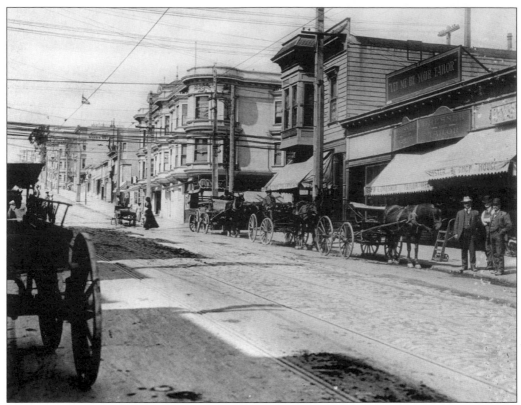

This image shows another view of Abraham's Pharmacy and Dresner Tailors, probably earlier in 1907. An "Oyster and Chop House" is next to the tailor. (Courtesy of the author.)

Eddie Hanlon's liquor store at 1949 Post (between Fillmore and Steiner on the corner of Avery Street) is shown here in 1907. (Courtesy of the author.)

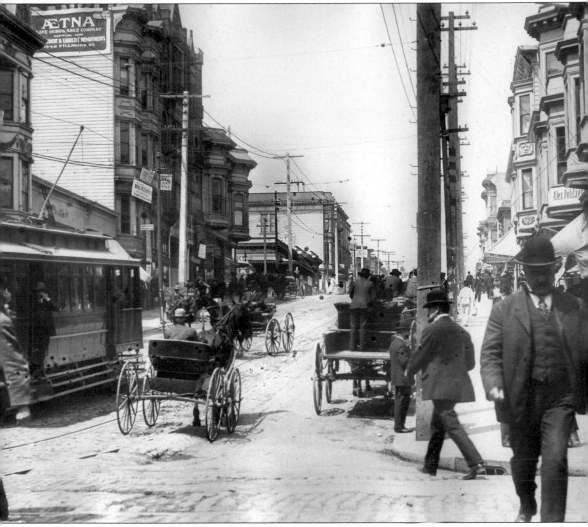

This photo shows Fillmore Street, looking north from Sutter. The Aetna Insurance office was at 1849 Fillmore. (Courtesy of the author.)

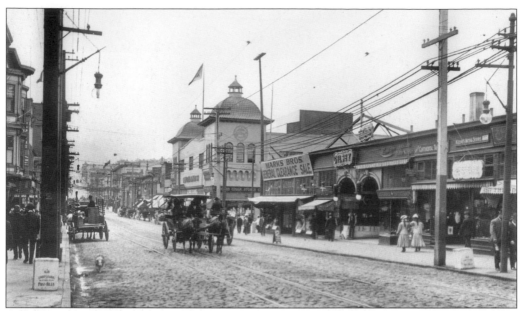

At 1800 Fillmore, Marks Brothers Ladies' Wear and Children's Wear was having a clearance sale in August 1907. (Courtesy of the author.)

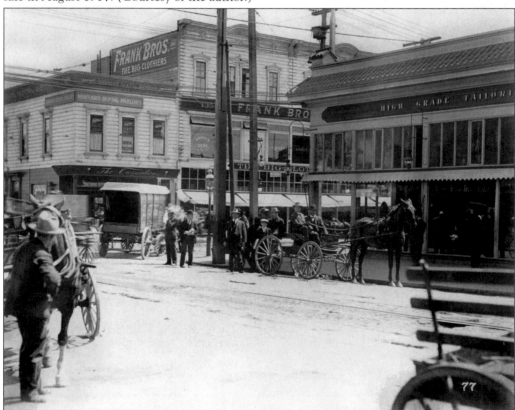

A few blocks to the south, at 1354 Fillmore, Franks Brothers called themselves "The Big Clothiers." (Courtesy of the author.)

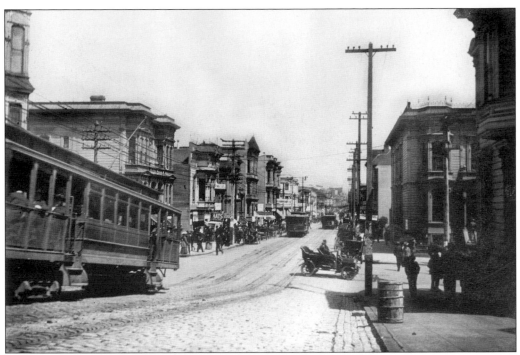

It is no wonder that by 1907, many merchant boosters were referring to Fillmore Street as "The New Market Street." (Courtesy of the author.)

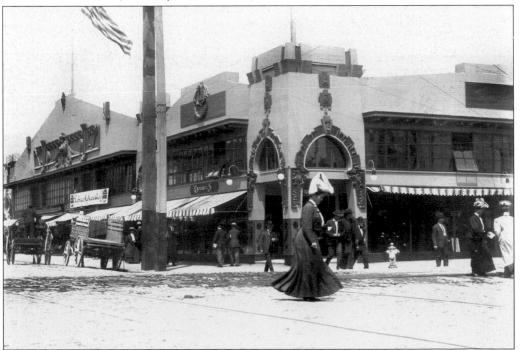

At the northeast corner of Geary and Fillmore in 1907, Sommer and Kaufmann (pictured on the left) sold boots and shoes, while Raphael's on the right sold clothing and men's furnishings. (Courtesy of the author.)

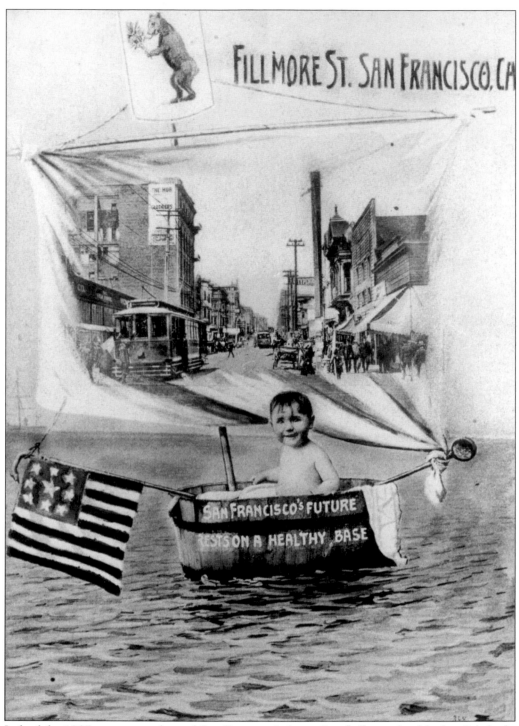

Indeed, by 1907 promoters claimed San Francisco's future "rest[ed] on a healthy base" (which, of course, was Fillmore Street). (Courtesy of the author.)

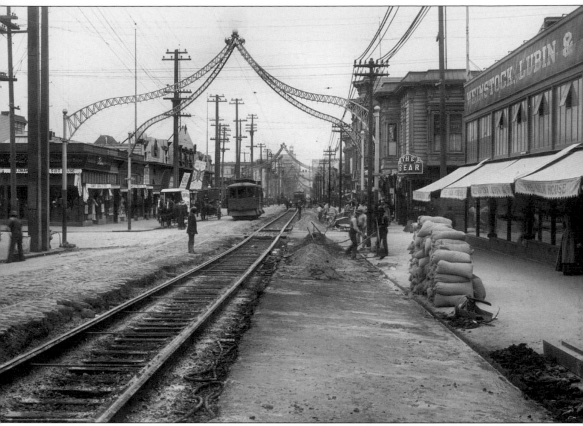

One of the major efforts to ensure the long-term prosperity of Fillmore Street was the 1907 installation of 14 iron arches at each intersection between Golden Gate and Sacramento Streets. Boosters claimed that the arches made Fillmore "the most highly illuminated street in America." They symbolized the street and made it instantly recognizable for 35 years, until they were removed for scrap iron to help the war effort in 1943. (Courtesy of Jerry Flamm.)

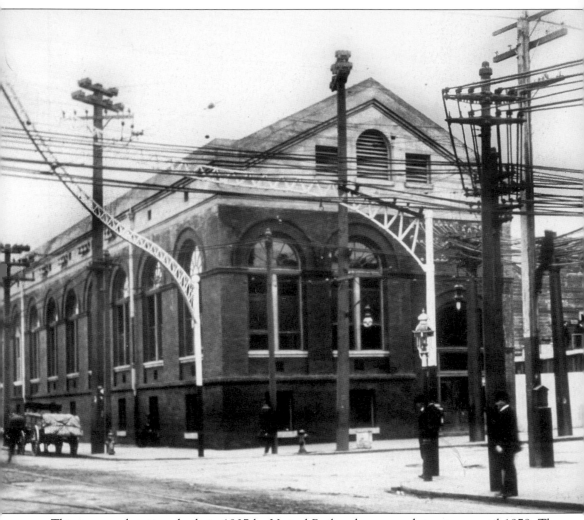

This power substation, built in 1907 by United Railroads, powered streetcars until 1978. The building, at the corner of Fillmore and Turk, still exists. United Railroads owner Patrick Calhoun, an ardent boxing fan, hired professional fighters and motormen and conductors, and built a gymnasium to the right of this picture in the space now occupied by a mini park. (Courtesy of Jerry Flamm.)

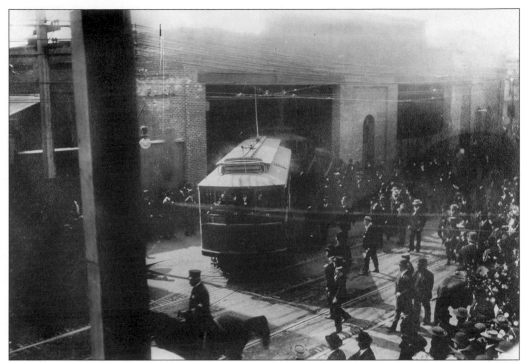

In 1907, a strike by streetcar operators led to a riot that resulted in three deaths. Emotions ran high when this first streetcar left the car barn on Fillmore and Turk, across the street from the power station shown in the previous photo. (Courtesy of the San Francisco History Center, San Francisco Public Library.)

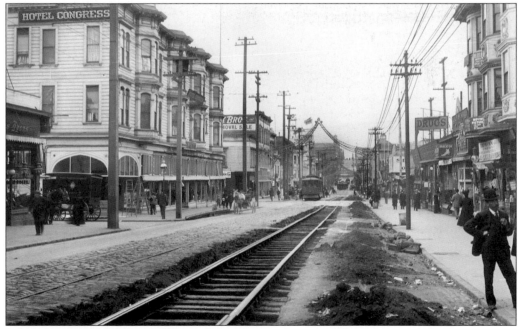

Fillmore, between Eddy and Ellis, is shown here in August 1909. Streetcar track improvements seem to be a neverending project. (Courtesy of Jerry Flamm.)

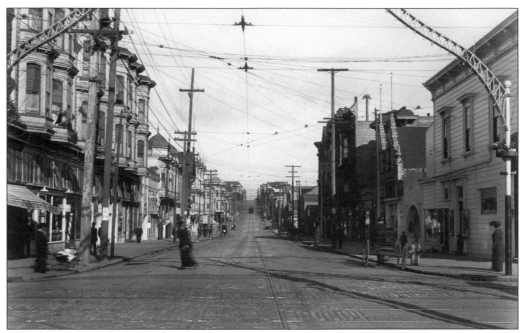

By 1914, the rebuilding of downtown San Francisco meant that the Fillmore was somewhat quieter than a few years earlier. Compare this September 30, 1914 view of Ellis Street, looking east from Fillmore, to the same intersection in 1907 on page 28. (Courtesy of Jerry Flamm.)

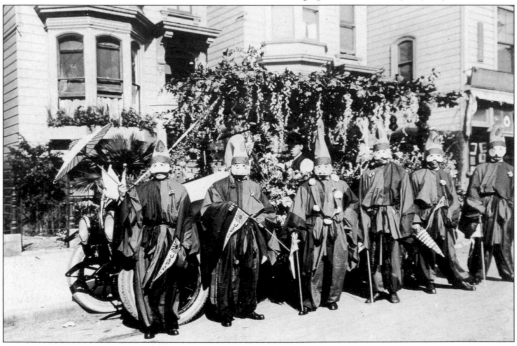

The Pan-Pacific Exposition of 1915 was San Francisco's proclamation to the world that the city was fully recovered from the earthquake and fire. In this photo, Japanese residents of the Fillmore, dressed in traditional costumes, prepare to participate in the festivities. (Courtesy of the San Francisco History Center, San Francisco Public Library.)

Three
AMUSEMENTS

From very early in the 20th century and continuing to this day, the Fillmore has been one of San Francisco's premier entertainment and amusement neighborhoods. The very broad scope of entertainment available included vaudeville, motion pictures, live theater, music (especially jazz and rock), boxing, dancing, roller and ice skating, and an amusement park called the Chutes.

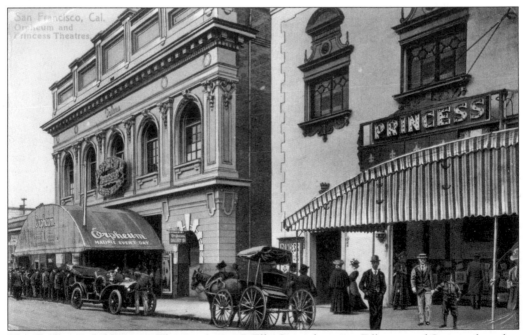

The Orpheum and Princess Theatres were on Ellis Street between Fillmore and Steiner for a few years after the 1906 earthquake. The Orpheum's previous location on O'Farrell (behind present-day Macy's) was destroyed. So from January 1907 to April 1909, the Fillmore was the city's major theatre district until the downtown location was rebuilt. (Courtesy of John Freeman.)

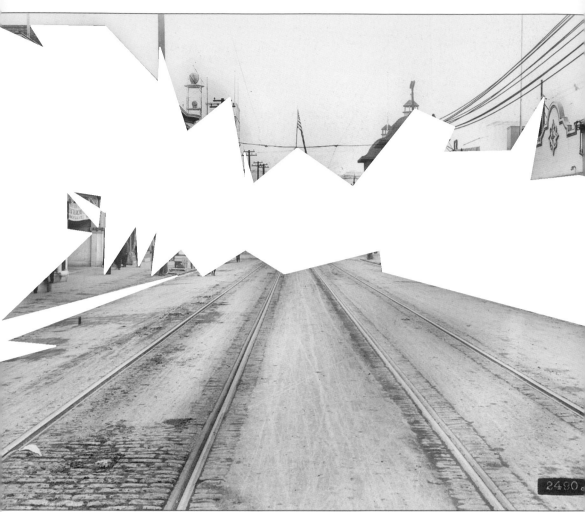

By 1909, the Chutes, a major amusement park modeled after similar parks in other major cities, was in the Fillmore. As land in earlier locations in the Haight and later the Richmond districts became more expensive, the park moved to the cheaper neighborhood. It covered the entire block of Fillmore, Webster, Eddy, and Turk Streets. This 1909 photo of Fillmore Street looking south, shows the Chutes sign on the left, just beyond the first arch. (Courtesy of Jerry Flamm.)

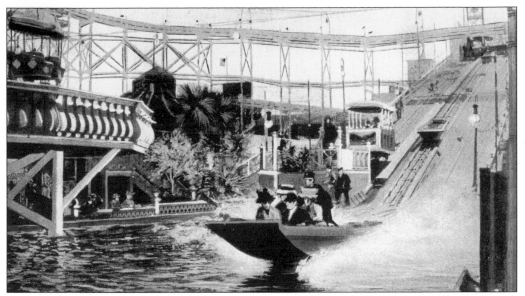

One of the major attractions at the Chutes was shooting the rapids. (Courtesy of John Freeman.)

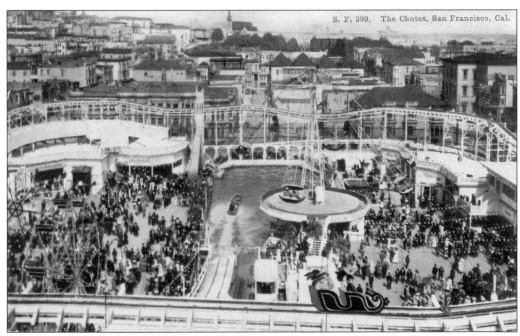

This interior view of the Chutes shows the Ferris wheel on the left, the chutes in the center, a miniature railroad on the perimeter, and an observation tower to the right of center. On the horizon is the steeple of St. Paulus Church on Gough Street. (Courtesy of John Freeman.)

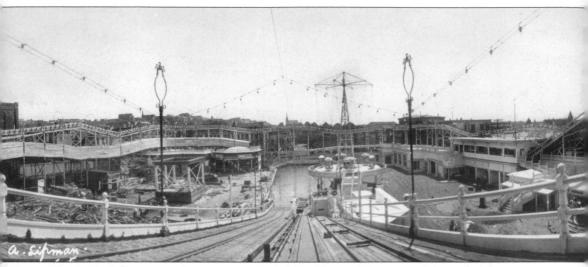

This picture depicts another interior view of the Chutes. (Courtesy of the author.)

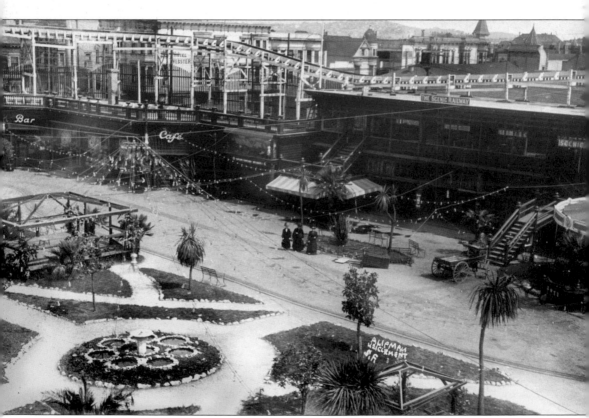

This photo shows the "Scenic Railroad," bar, café, and gardens. (Courtesy of the author.)

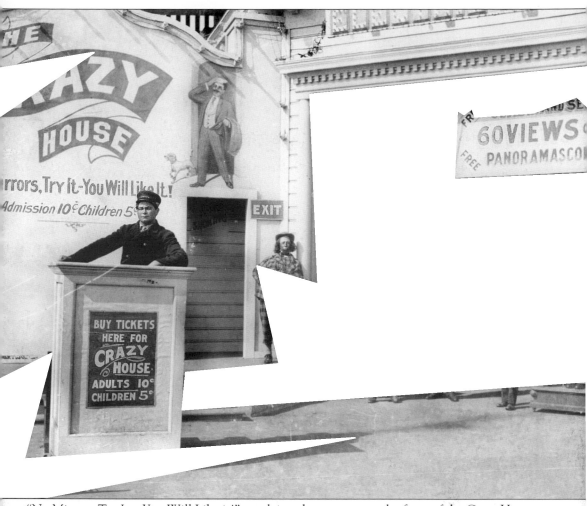

"No Mirrors. Try It—You Will Like it!" proclaims the message on the front of the Crazy House. (Courtesy of the author.)

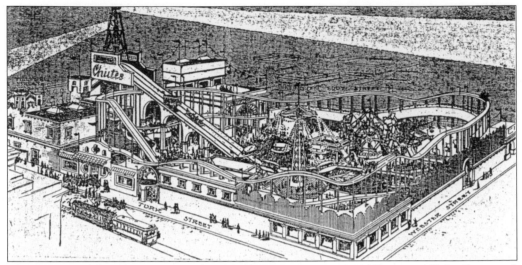

This drawing of the Chutes appeared in San Francisco newspapers. (Courtesy of John Freeman.)

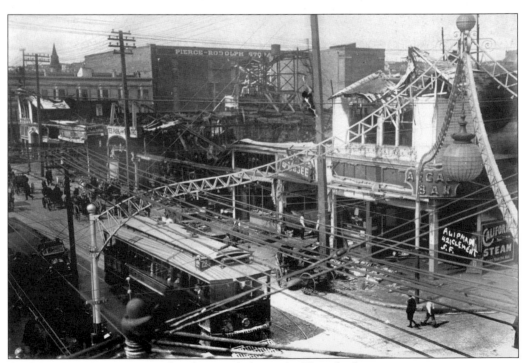

On May 29, 1911, a major fire destroyed the park. Though there were promises to reopen "soon," the damage was too great and the Chutes closed forever. (Courtesy of John Freeman.)

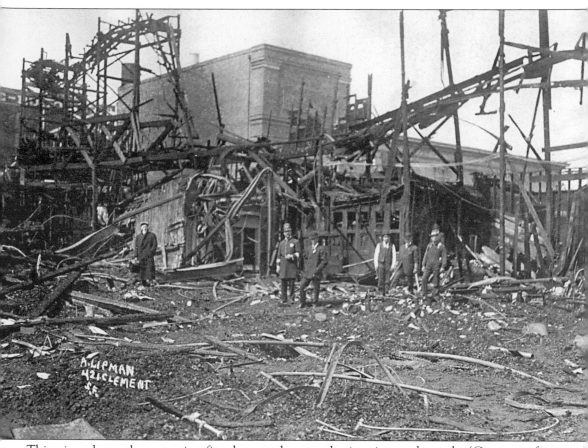

This view shows the extensive fire damage done to the interior to the park. (Courtesy of the author.)

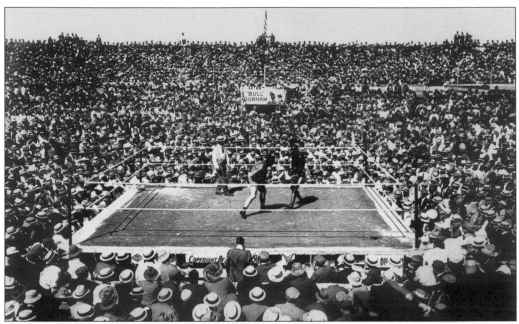

The Jim Jeffries–Jack Johnson heavyweight title fight, on the Fourth of July, 1910, was originally scheduled for the Dreamland Rink in the Fillmore. Anti-boxing crusaders, however, convinced Governor James N. Gillett to outlaw the fight. It was moved to Reno, where the former white champ, Jeffries, who had originally refused to fight the black challenger Johnson, lost. The outcome resulted in some of the worst racial violence in American history. (Courtesy of Jerry Flamm.)

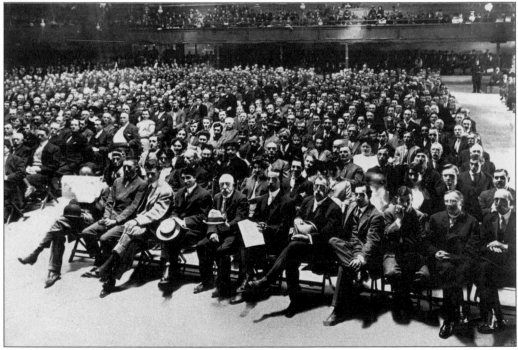

Undeterred by the fight's move to Reno, fans turned out anyway to the Dreamland Rink to hear a blow-by-blow account, delivered over a telegraph line. (Courtesy of Jerry Flamm.)

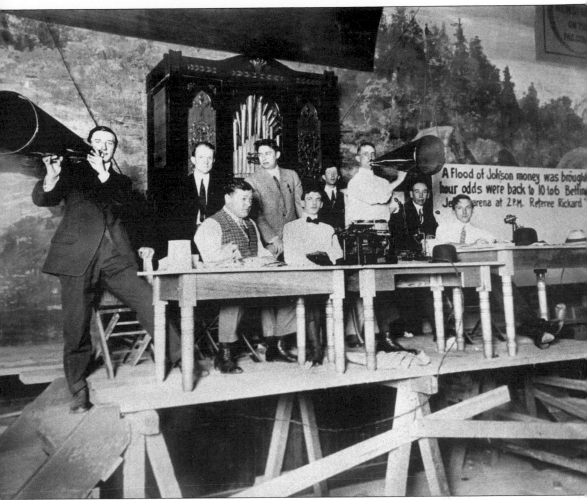

As the news came through, the announcer informed the crowd of the situation. (Courtesy of Jerry Flamm.)

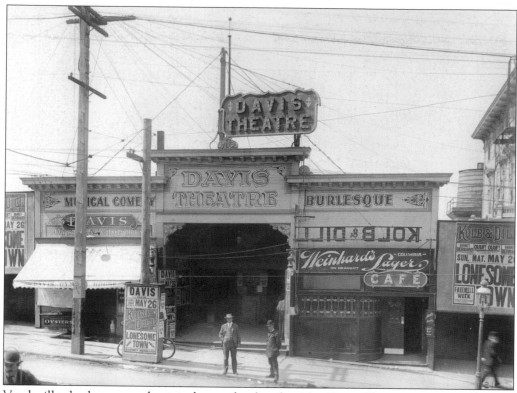

Vaudeville, burlesque, and musical comedy played at the Davis Theatre on McAllister and Fillmore. Clarence Kolb and Max Dill, leading vaudevillians, were performing when this photo was taken in May 1907. (Courtesy of the author.)

The oldest existing theatre in the Fillmore is now called the Fillmore Auditorium. Built by Emma Gates Butler, the Italianate-style building was both a dance hall and auditorium when it opened in 1912 as the Majestic Hall and the Majestic Academy of Dancing. (Courtesy of the San Francisco History Center, San Francisco Public Library.)

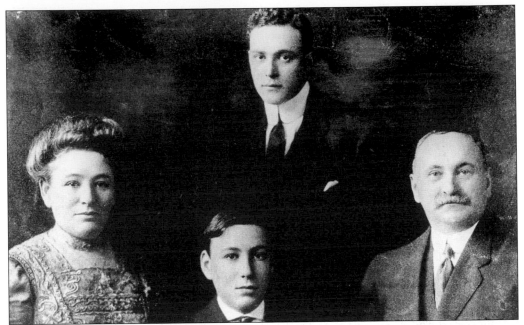

The Friedlander Family, shown here in 1910, became the second owners of the auditorium in 1922. They continued to own it for the next 30 years, operating it in the 1940s as the Ambassador Roller Skating Rink. (Courtesy of the San Francisco History Center, San Francisco Public Library.)

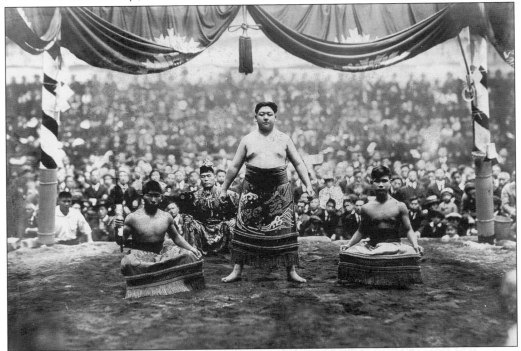

Sumo wrestling attracted large crowds to Dreamland Auditorium, Post and Steiner, in the 1920s. This wrestler was Charles Kikugawa. (Courtesy of the San Francisco History Center, San Francisco Public Library.)

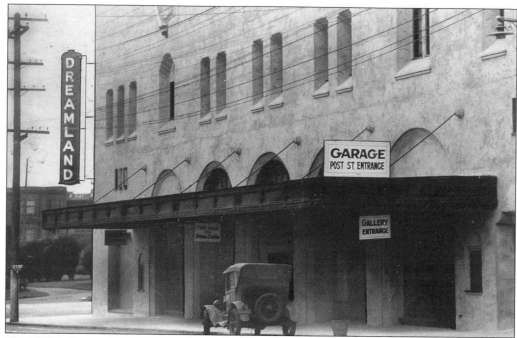

This 1928 photo shows an exterior view of Dreamland Auditorium. (Courtesy of the San Francisco History Center, San Francisco Public Library.)

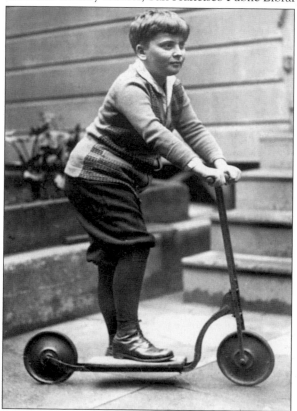

Many artists and entertainers who grew up in the Fillmore would find fame and fortune elsewhere. The violinist Yehudi Menuin, shown here as a boy around 1925, lived with his parents on 1043 Steiner Street. Other Fillmore artists included poet Maya Angelou, violinist Isaac Stern, and comedian Mel Blanc. (Courtesy of Jerry Flamm.)

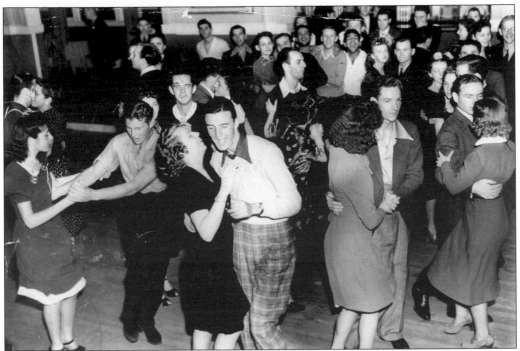

Dreamland Auditorium also provided a venue for these jitterbuggers in October 1938. (Courtesy of the San Francisco History Center, San Francisco Public Library.)

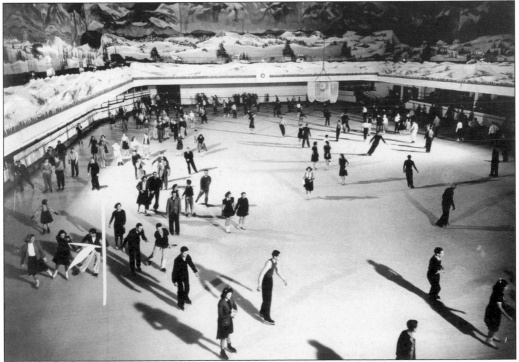

The name of Dreamland changed to Winterland by the time this photo was taken in 1940. (Courtesy of the San Francisco History Center, San Francisco Public Library.)

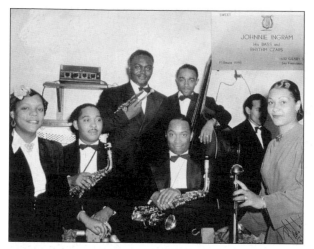

From the 1940s through the 1960s the Fillmore was best known for jazz. The "Harlem of the West" had many clubs that drew crowds nightly. In the 1940s, Johnnie Ingram and his band, shown here at Jack's Tavern at 1931 Sutter, were frequent performers in the neighborhood. Shown here, from left to right, are: Betty Allen (pianist), Willie James (sax), McKissic London Holmes (trumpet), Charles Whitfield(sax), Johnnie Ingram (bass), Delmar Smith (trumpet), and Evelyn Myers (singer). (Courtesy of Johnnie Ingram.)

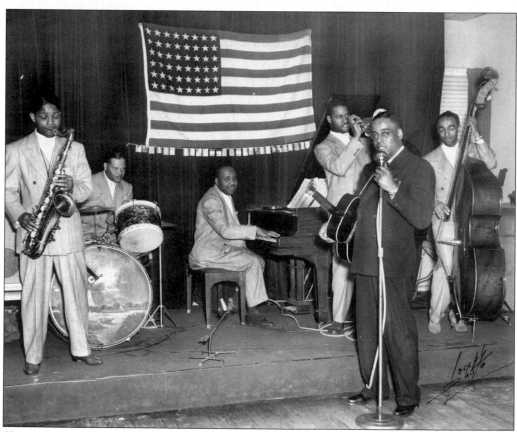

Shown here in the 1950s at the California Theatre Club at 1850 Post Street, from left to right, are: John Henton (sax), Norville Maxey (drums), Lee Dedmon (piano), Otto Sampson (trumpet), and Johnnie Ingram (bass). The master of ceremonies is Nate Christ. (Courtesy of Johnnie Ingram.)

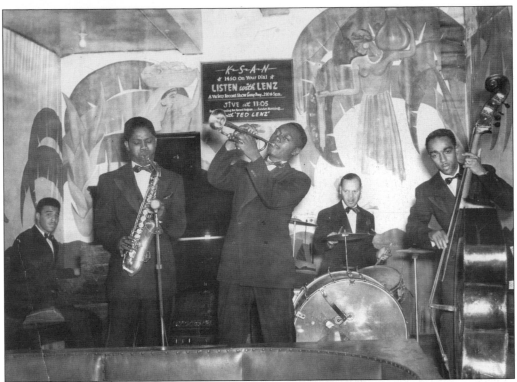

Shown here at the Subway Club in 1944, from left to right, are: David Richards (piano), John Henton (sax), McKissic London Holmes (trumpet), and Johnnie Ingram (bass). The Subway Club was in North Beach, and it was unusual for African-American bands to appear in clubs in that neighborhood. Owner Westley Johnson later opened clubs in the Fillmore. (Courtesy of Johnnie Ingram.)

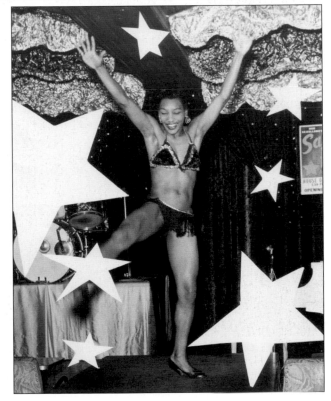

Dancers such as "Lottie the Body" often performed while the bands played. (Courtesy of Johnnie Ingram.)

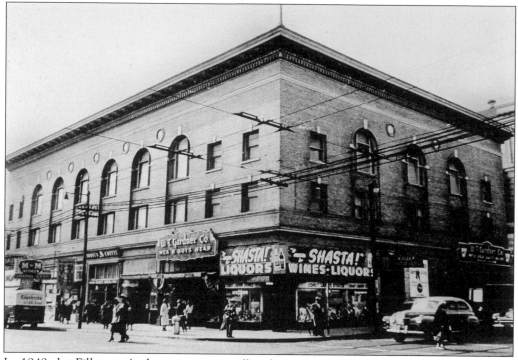

In 1949 the Fillmore Auditorium was a roller skating rink. (Courtesy of the San Francisco History Center, San Francisco Public Library.)

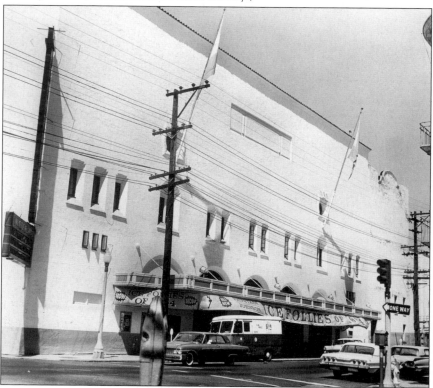

Ice skating was still popular at Winterland in 1964. (Courtesy of the San Francisco History Center, San Francisco Public Library.)

Movies replaced the vaudeville shows by the 1930s. The Uptown Theatre (previously called the Sutter Theatre) was at Sutter and Steiner. This photo dates from 1949, when the theatre showed *My Dream is Yours,* with Doris Day and Jack Carson. (Courtesy of the author.)

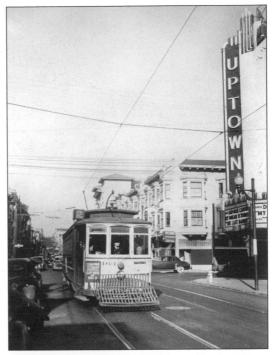

The Fillmore Auditorium had a rebirth in the 1960s, when promoter Bill Graham converted it from a rundown roller skating rink into a national center for rock concerts. In 1966, Graham began the practice of giving out apples from this container to help "hippies" get their vitamins. (Courtesy of the San Francisco History Center, San Francisco Public Library.)

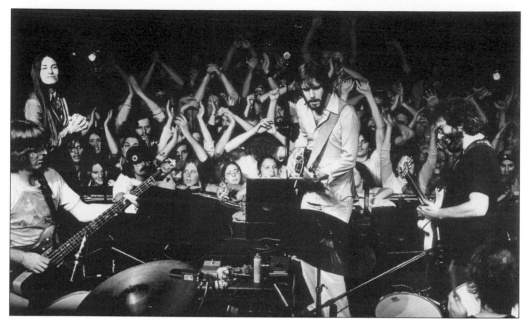

Graham also produced shows in the larger Winterland a few blocks away. This 1977 photo shows the Grateful Dead there. The aging and crumbling arena would close the following year. (Courtesy of Greg Gaar.)

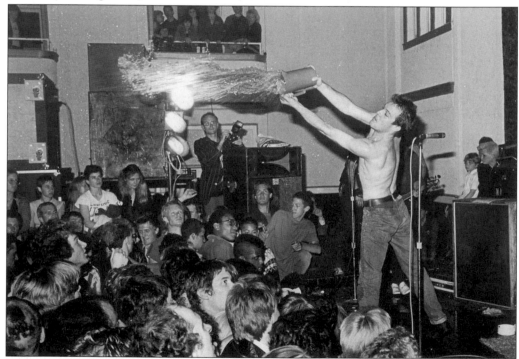

When Graham moved on from the Fillmore Auditorium, it was renamed the Elite Club for a time during the 1970s and 1980s. The shows produced during that period often included punk rock, such as this 1981 performance by Jello Biafra and the Dead Kennedys. Biafra had run (unsuccessfully) for mayor of San Francisco three years earlier. (Courtesy of Greg Gaar.)

Four
BETWEEN THE WARS

Though most of the major department stores and theatres moved back to their downtown locations by 1915, the Fillmore continued to be a major commercial district supporting an increasingly racially and culturally diverse population living in a relatively inexpensive part of the city. The neighborhood had a substantial Jewish population, a growing Japanese presence, as well as Chinese, Russians, Filipinos, whites, and a small African-American population living in relative harmony without the rigid segregation that characterized most American cities at the time. There were three synagogues, kosher butchers and restaurants, and a Yiddish cultural center, as well as Japanese groceries and bakeries, and African-American barber and beauty shops.

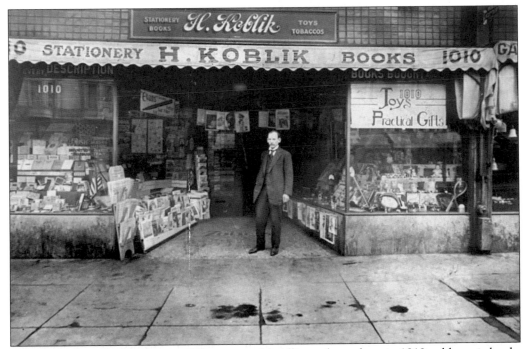

Harry Koblic's stationery store on Fillmore near McAllister, shown here in 1919, sold comic books to the neighborhood kids and was a popular hangout for neighborhood liberals. Koblic himself would later run unsuccessfully for mayor on the Socialist ticket. (Courtesy of Jerry Flamm.)

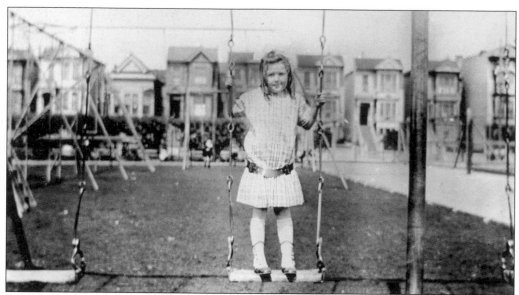

Lorraine Dillon played in Hamilton Square Park in 1917. (Courtesy of the San Francisco History Center, San Francisco Public Library.)

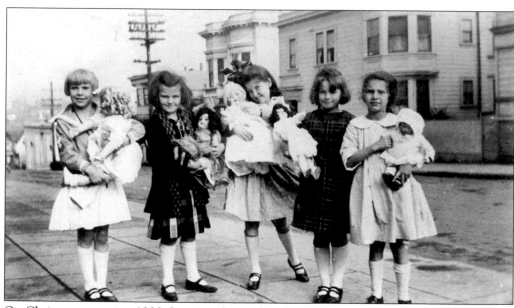

On Christmas morning 1922, Lorraine (center) and her friends show off their presents at the corner of Eddy and Broderick. (Courtesy of the San Francisco History Center, San Francisco Public Library.)

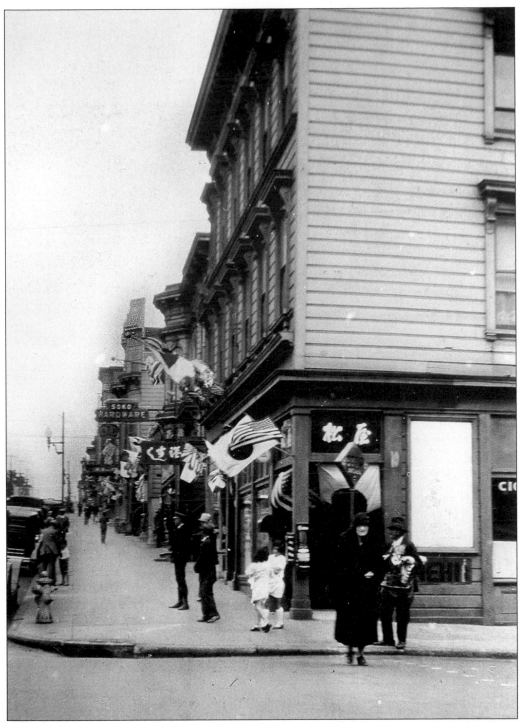

Matsuya Store, on the southeast corner of Post and Buchanan, sold confectioneries for most of the 1920s before closing in 1931. Note that Soko Hardware is shown halfway down the block in its original location. Japan Center now occupies this block. (Courtesy of the San Francisco History Center, San Francisco Public Library.)

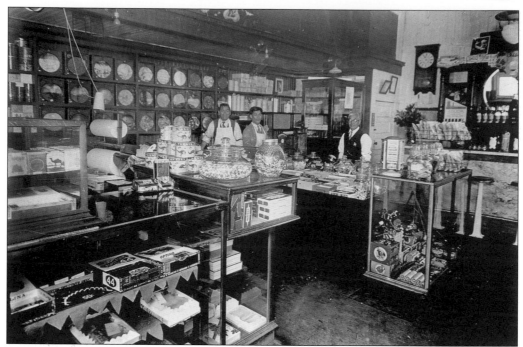

In addition to confectioneries, this interior view of Matsuya Store suggests that there was also a strong demand for cigarettes and cigars. (Courtesy of the San Francisco History Center, San Francisco Public Library.)

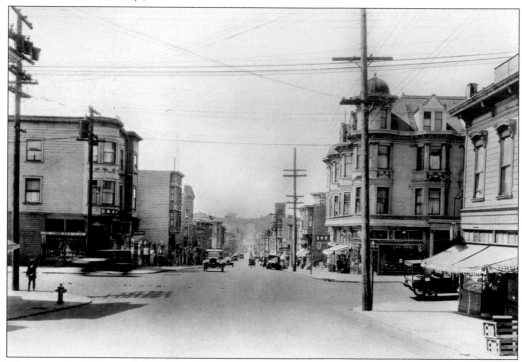

The corner of Post and Laguna was the heart of Japantown. This photo was taken in 1927. (Courtesy of the San Francisco History Center, San Francisco Public Library.)

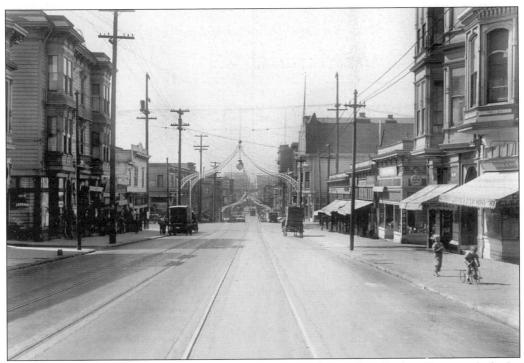

Neighborhood businesses, shown in this 1919 view of Fillmore from Bush to Pine, include (at right) a cleaning and dyeing store, a watchmaker, and a paint store. (Courtesy of Jerry Flamm.)

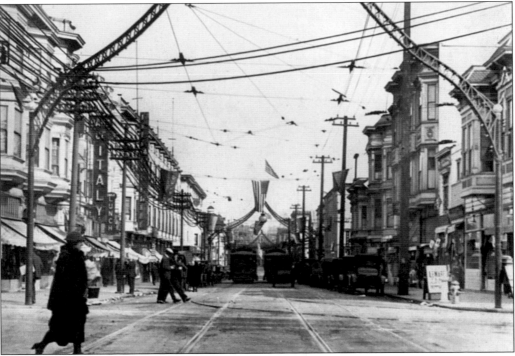

To the south in the same year (1919) Fillmore and McAllister had a branch of the Bank of Italy (left), which later became Bank of America. (Courtesy of Jerry Flamm.)

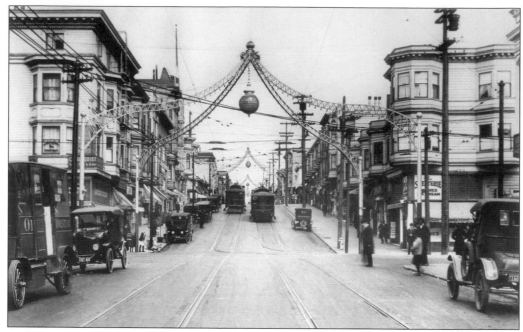

At Fillmore and Sutter in 1920, one could visit a chiropodist ("Arches Made to Order") on the left and then walk across the street for sundaes and ice cream. The Model T behind the van, at the far left, was a jitney cab to the Ferry Building. (Courtesy of the author.)

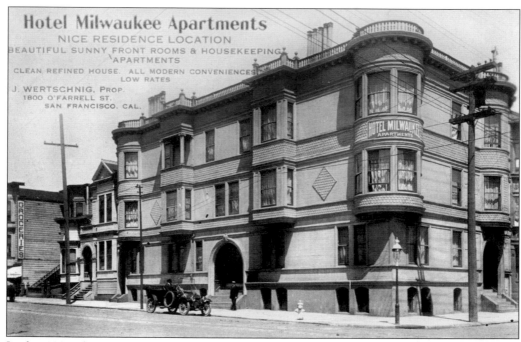

In this 1920 photo, The Hotel Milwaukee Apartments offered a "clean refined house" with "all modern conveniences," and "low rates" to boot. It was on the corner of O'Farrell and Fillmore. (Courtesy of the author.)

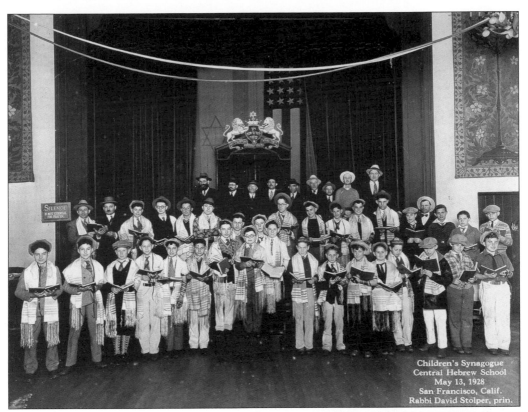

Children's Synagogue
Central Hebrew School
May 13, 1928
San Francisco, Calif.
Rabbi David Stolper, prin.

The Central Hebrew School, shown here, was at Grove and Buchanan Streets. (Courtesy of the San Francisco History Center, San Francisco Public Library.)

Louis Frucht owned the Practical Hat and Umbrella Works at 1132 Fillmore, between Golden Gate and Turk. This photo was taken around 1920. (Courtesy of Jerry Flamm.)

Louis Frucht's nephew Jerry Flamm posed behind his uncle's 1917 Dodge sedan around 1920. (Courtesy of Jerry Flamm.)

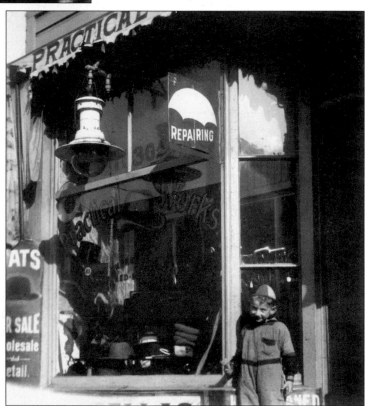

Jerry Flamm posed in front of his uncle's store around 1920. (Courtesy of Jerry Flamm.)

Jerry Flamm again is shown in front of his uncle's store around 1922. (Courtesy of Jerry Flamm.)

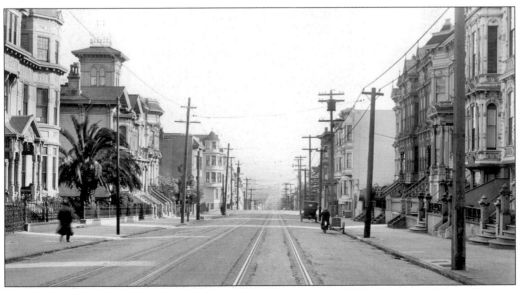

This image depicts McAllister Street at Scott, looking east in 1929. (Courtesy of Jerry Flamm.)

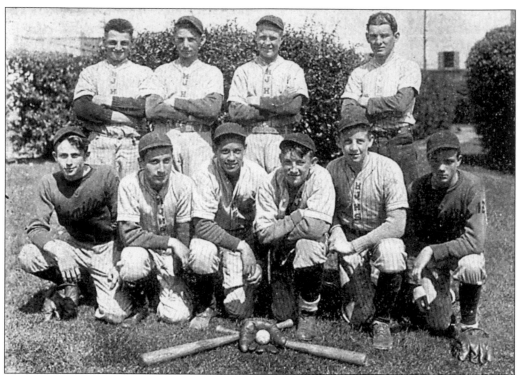

Jerry Flamm is second from the left in the back row of this late 1920s photo of the Hamilton Junior High School baseball team. (Courtesy of Jerry Flamm.)

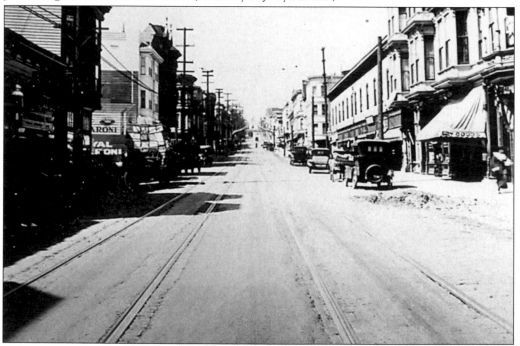

This 1927 photo displays McAllister Street, looking west from Buchanan. (Courtesy of Jerry Flamm.)

The
intersection of
Fillmore and
McAllister,
shown here in
1930, is
decorated for
Christmas.
(Courtesy of
Jerry Flamm.)

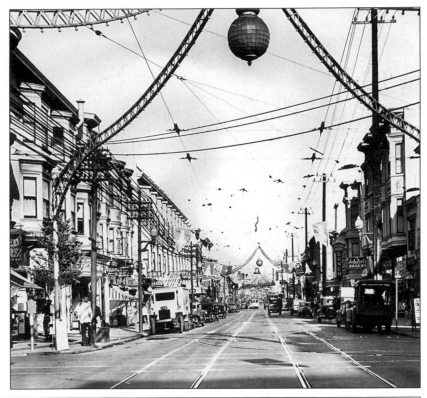

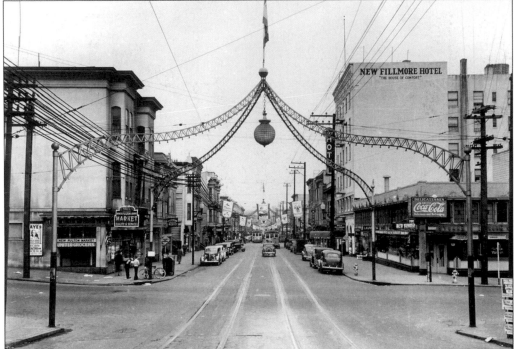

This is a photo of Fulton and Fillmore Streets in December 1936. The New Fillmore Hotel was at 930 Fillmore. (Courtesy of the San Francisco History Center, San Francisco Public Library.)

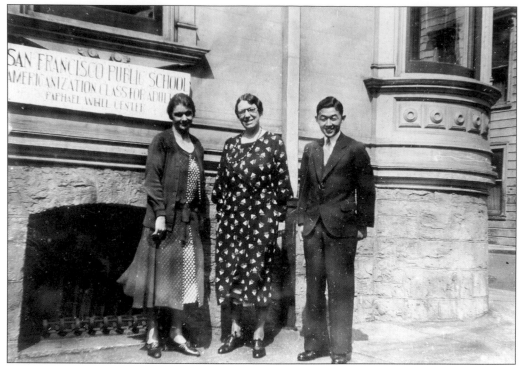

The San Francisco Public Schools offered an "Americanization Class for Adults" at the Raphael Weill Center on 1223 Buchanan. In this 1934 photo, the two women are teachers and the man a student. (Courtesy of the San Francisco History Center, San Francisco Public Library.)

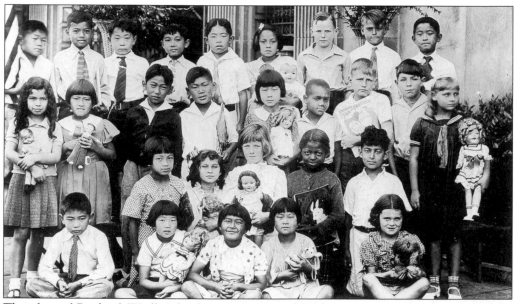

The class of Raphael Weill School, near Geary and Webster, suggests the diversity of the neighborhood in 1935. It is now called Rosa Parks School. (Courtesy of the San Francisco History Center, San Francisco Public Library.)

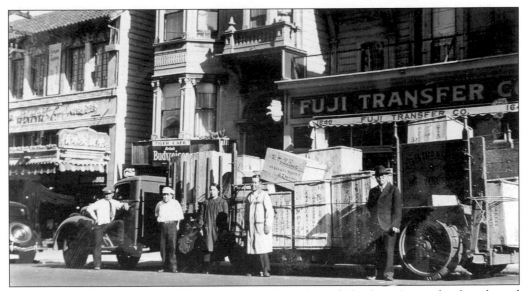

Fuji Transfer Company, at 1640 Post Street, shipped goods back to Japan for friends and relatives. This photo was taken in the 1930s. (Courtesy of the San Francisco History Center, San Francisco Public Library.)

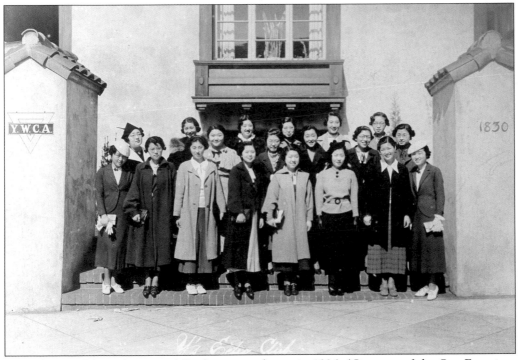

Here the YWCA, at Sutter and Buchanan, is shown in 1936. (Courtesy of the San Francisco History Center, San Francisco Public Library.)

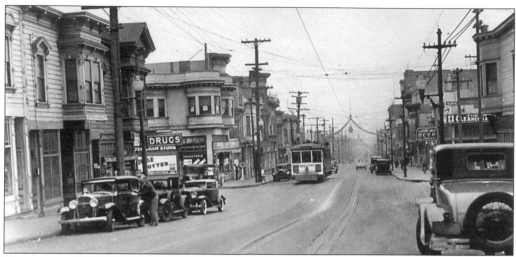

This is a view of Fillmore and Clay on July 31, 1934. (Courtesy of the author.)

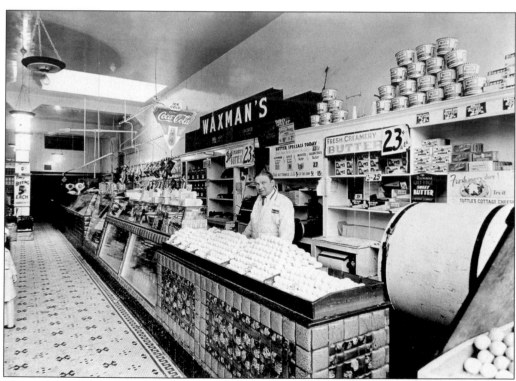

The Eagle Market, often called "the Jewish Market," was on Fillmore between Eddy and Ellis. George Bloom, the owner, is shown in this 1940s photo. (Courtesy of the San Francisco History Center, San Francisco Public Library.)

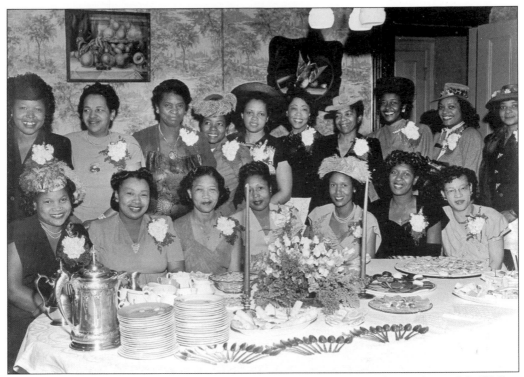

Fillmore beauticians held monthly "Beauticians' Club" meetings at the Madame C.J. Walker Home for Girls and Women at 2066 Pine Street in the late 1930s. The home, established in 1921 to aid African-American women, was named for one of the first black woman millionaires. But the home also served, as shown here, as a social gathering place for many black organizations. (Courtesy of the San Francisco History Center, San Francisco Public Library.)

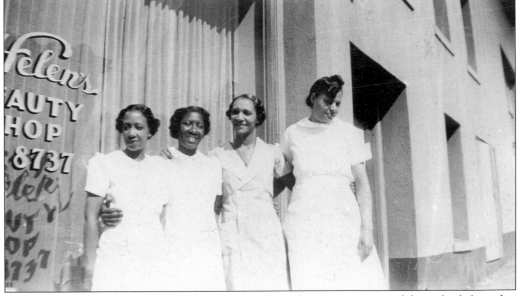

Helen's Beauty Shop was at 1343 Buchanan. Helen, the owner, is second from the left in this 1940 photo. (Courtesy of the San Francisco History Center, San Francisco Public Library.)

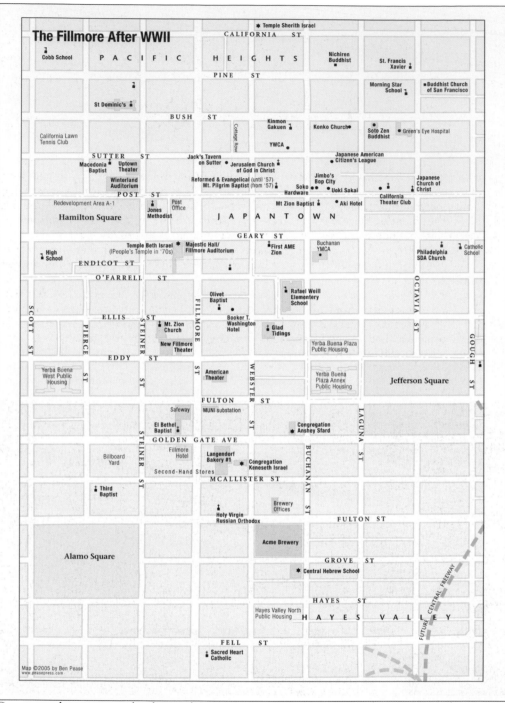

The Fillmore After WWII

Temple Sherith Israel

CALIFORNIA ST

Cobb School

PACIFIC HEIGHTS

Nichiren Buddhist

St. Francis Xavier

PINE ST

Morning Star School

Buddhist Church of San Francisco

St Dominic's

BUSH ST

California Lawn Tennis Club

Cottage Row

Kinmon Gakuen

Konko Church

Soto Zen Buddhist

Green's Eye Hospital

YWCA

SUTTER ST

Jack's Tavern on Sutter

Japanese American Citizen's League

Macedonia Baptist Uptown Theater

Jerusalem Church of God in Christ

Jimbo's Bop City

Winterland Auditorium

Reformed & Evangelical (until '57)
Mt. Pilgrim Baptist (from '57)

Soko Hardware

Uoki Sakai

Japanese Church of Christ

POST ST

Redevelopment Area A-1

Post Office

Mt Zion Baptist

Aki Hotel

California Theater Club

Hamilton Square

Jones Methodist

JAPANTOWN

GEARY ST

Temple Beth Israel
(IPeople's Temple in '70s)

Majestic Hall/
Fillmore Auditorium

First AME Zion

Buchanan YMCA

Philadelphia SDA Church

Catholic School

High School

ENDICOT ST

O'FARRELL ST

Olivet Baptist

Rafael Weill Elementery School

SCOTT ST

ELLIS ST

FILLMORE

Booker T. Washington Hotel

Glad Tidings

PIERCE

STEINER ST

Mt. Zion Church

New Fillmore Theater

Yerba Buena Plaza Public Housing

OCTAVIA ST

GOUGH

EDDY ST

American Theater

WEBSTER ST

Yerba Buena Plaza Annex Public Housing

Jefferson Square

Yerba Buena West Public Housing

FULTON ST

Safeway

MUNI substation

El Bethel Baptist

Congregation Anshey Sfard

LAGUNA ST

GOLDEN GATE AVE

Billboard Yard

Fillmore Hotel

Langendorf Bakery #1

Congregation Keneseth Israel

BUCHANAN ST

STEINER ST

Second-Hand Stores

MCALLISTER ST

Third Baptist

Brewery Offices

Holy Virgin Russian Orthodox

FULTON ST

Acme Brewery

Alamo Square

GROVE ST

Central Hebrew School

HAYES ST

Hayes Valley North Public Housing

HAYES VALLEY

FUTURE CENTRAL FREEWAY

FELL ST

Sacred Heart Catholic

Map ©2005 by Ben Pease
www.peasepress.com

Compare this map with the earlier one on page 20 to see the postwar changes in the neighborhood.

74

Five

THE 1940S

World War II brought radical changes to the Fillmore. After the attack on Pearl Harbor on December 7, 1941, Japanese people living in the United States, citizen and immigrant alike, came under deep suspicion. Some were arrested in San Francisco while the fires still burned in Hawaii. Within months, Pres. Franklin Roosevelt issued an order to round up all Japanese on the West Coast (but not in Hawaii) and move them to remote detention camps.

With only a matter of days to prepare, Fillmore residents did what they could to protect their homes and businesses before reporting to nearby evacuation centers. Within days, Japantown was deserted.

Before long, African Americans seeking well-paying wartime jobs moved to San Francisco and other West Coast cities from all over the country. Homes and apartments in the Fillmore, emptied by evacuated Japanese families, provided housing opportunities. Since the neighborhood already had a small black population, the newcomers, at least at first, found little difficulty in obtaining housing in the area.

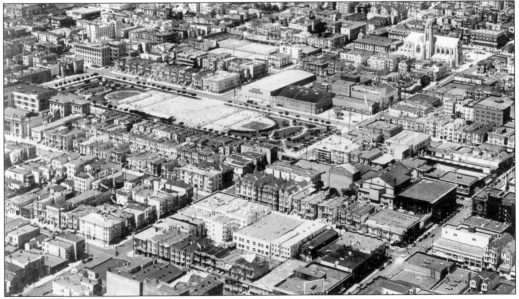

This aerial photo, probably dating from the late 1930s or early 1940s, shows the intersection of Fillmore and Geary Street at the lower right. The Fillmore Auditorium is on the corner (just below the center of the picture); St. Dominic's Church on Bush at Steiner is at the upper right. Dreamland Skating Rink is near the center, above the Hamilton Recreation Center. (Courtesy of the San Francisco History Center, San Francisco Public Library.)

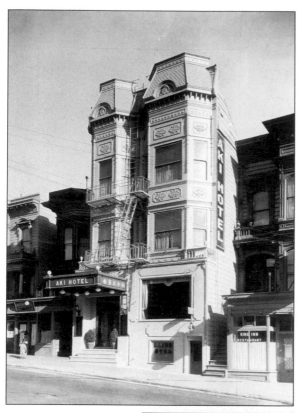

The Aki Hotel, on Post near Laguna, was the subject of an FBI raid on December 7, 1945. Everyone inside was detained and the owner, Ichiro Katakoa, an immigrant and a prominent civic leader in the Japanese community, was arrested. Note the public bath in the basement. (Courtesy of San Francisco History Center, San Francisco Public Library.)

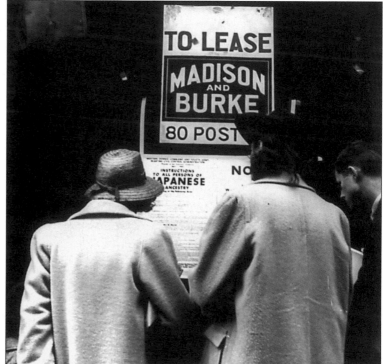

Copies of the executive order for the removal of all citizens of Japanese ancestry were posted through the city. (Courtesy of the Library of Congress.)

This posting at First and Front Streets set the deadline for evacuation at April 7, 1942. (Courtesy of the Library of Congress.)

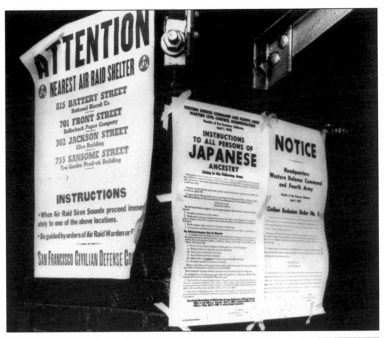

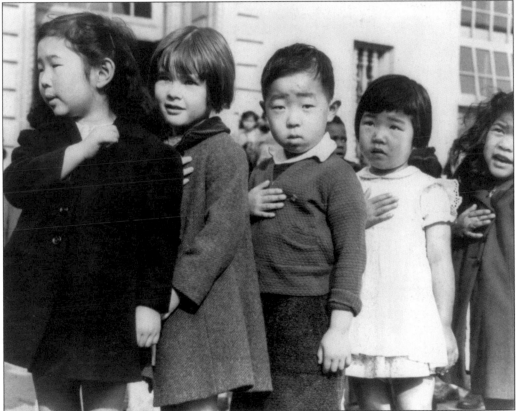

Children at Raphael Weill elementary school pledged allegiance to the flag in the days before the evacuation. (Courtesy of the Library of Congress.)

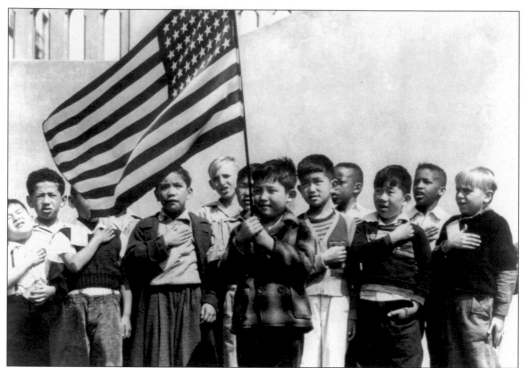

This photo, taken in early April, again reflects the racial diversity of schools in the Fillmore. (Courtesy of the Library of Congress.)

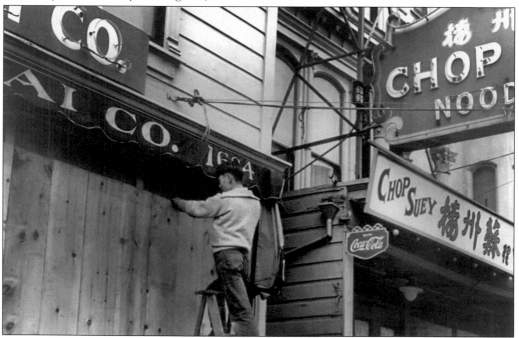

Katsu Sakai boards up the front of his family's store, Uoki K. Sakai Grocery, at 1684 Post Street. The grocery is now a few doors down the block at 1656 Post. (Courtesy of the Library of Congress.)

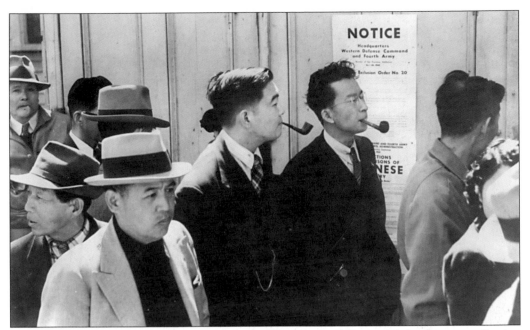

The first group of 664 evacuees reported to the Wartime Civil Control Administration Station at Van Ness and Sacramento Street in early April. They were to be housed in War Relocation Authority Centers for the duration of the war. (Courtesy of the Library of Congress.)

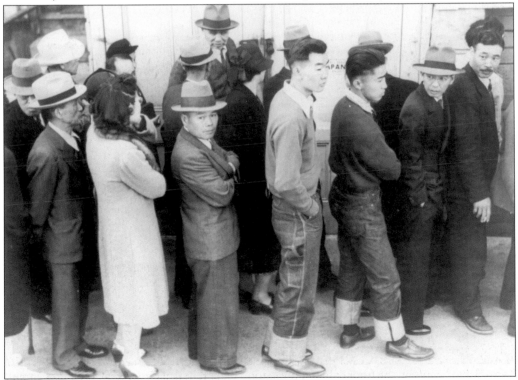

Seen here are more people waiting in the registration line. (Courtesy of the Library of Congress.)

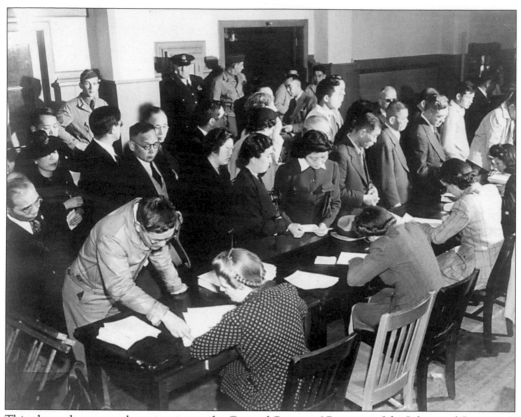
This photo shows people registering at the Control Station. (Courtesy of the Library of Congress.)

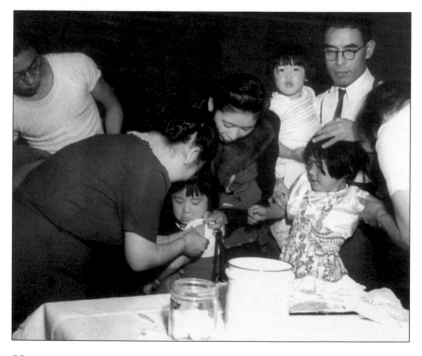
Inoculation was part of the registration process, as depicted in this image. (Courtesy of the Library of Congress.)

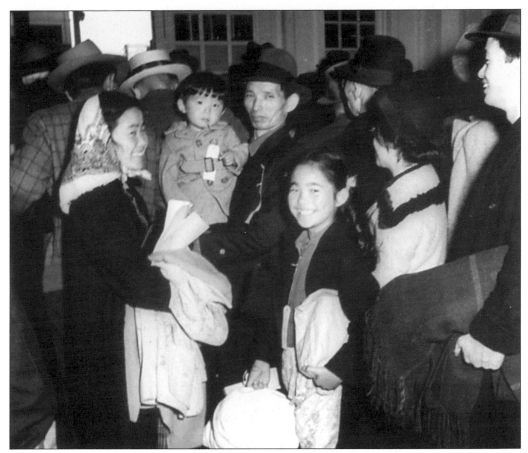

More of the first group is seen here waiting at the station on Van Ness. (Courtesy of the Library of Congress.)

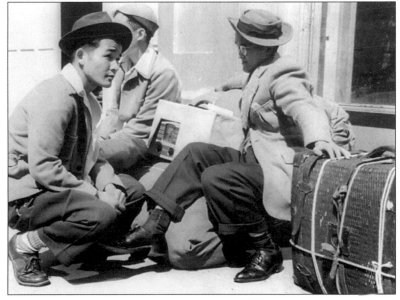

After registration, the evacuees packed essential belongings and went to Jackson Street to catch buses for temporary relocation. (Courtesy of the Library of Congress.)

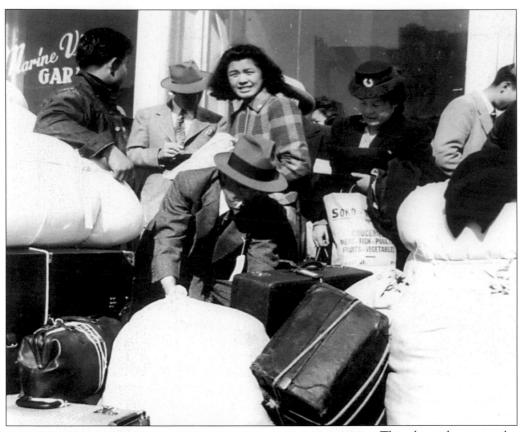

This photo shows people waiting for the bus. (Courtesy of the Library of Congress.)

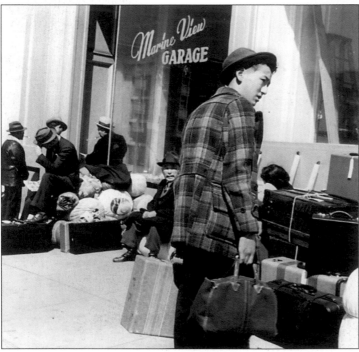

Another man waits for a bus to the temporary relocation center. (Courtesy of the Library of Congress.)

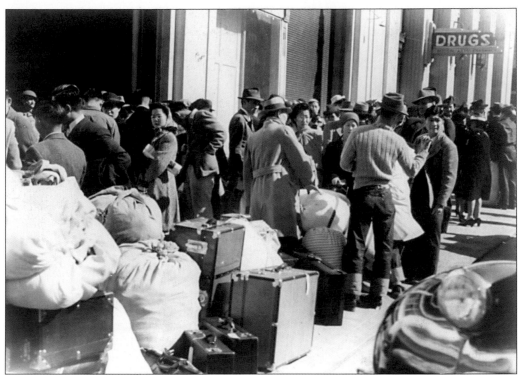

This is another image depicting people waiting at the relocation center. (Courtesy of the Library of Congress.)

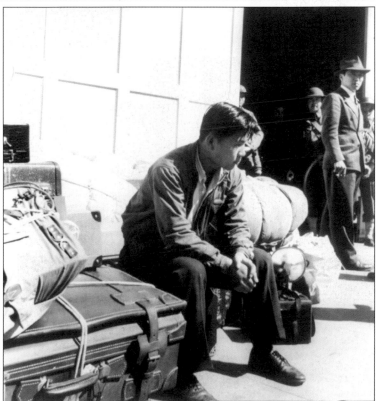

This man seems lost in thought as he waits. (Courtesy of the Library of Congress.)

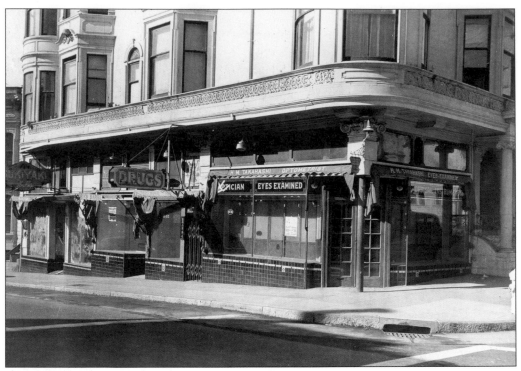

This February 1943 *Associated Press* photo, which appeared in San Francisco and other newspapers, was titled "The Japs Have Gone." It shows the deserted corner of Post and Laguna. Empty windows, boarded-up stores, and "to let" signs are all evident. (Courtesy of San Francisco History Center, San Francisco Public Library.)

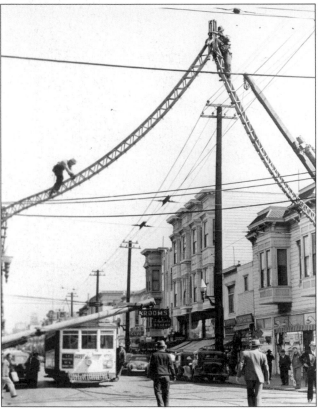

A few months later Fillmore Street still showed many signs of life, but workmen here begin to dismantle the arches, long the symbol of the neighborhood, to use the iron in support of the war effort. (Courtesy of the San Francisco History Center, San Francisco Public Library.)

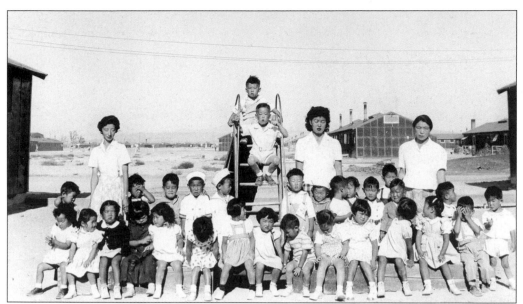

Most San Francisco evacuees ended up at a camp in Topaz, Utah. This photo shows the kindergarten class at the camp. (Courtesy of the San Francisco History Center, San Francisco Public Library.)

Back in San Francisco, students at Girls High School were recruited to help harvest grapes and tomatoes in Pleasanton to aid the war effort. Two teachers and the school's principal pose before a bus about to leave for the fields in the East Bay. (Courtesy of the San Francisco History Center, San Francisco Public Library.)

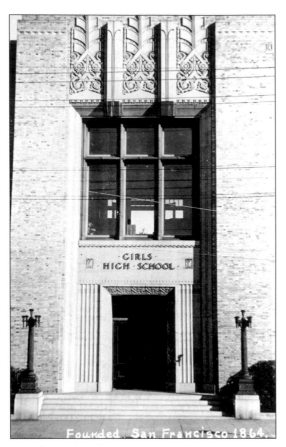

Girls High School (now Benjamin Franklin Middle School), founded in 1864, was at Geary and Scott. (Courtesy of the San Francisco History Center, San Francisco Public Library.)

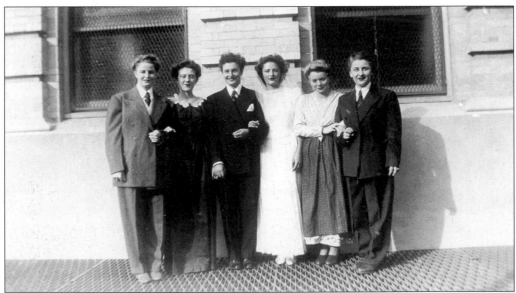

The cast of the Girls High School production of Thornton Wilder's *Our Town* posed in this 1942 photo. Girls played both the male and female roles in the play. (Courtesy of the San Francisco History Center, San Francisco Public Library.)

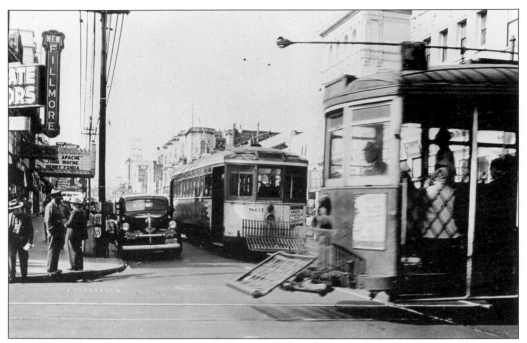

This 1948 photo of the corner of Eddy and Fillmore shows that the neighborhood was still vibrant after the war. (Courtesy of San Francisco History Center, San Francisco Public Library.)

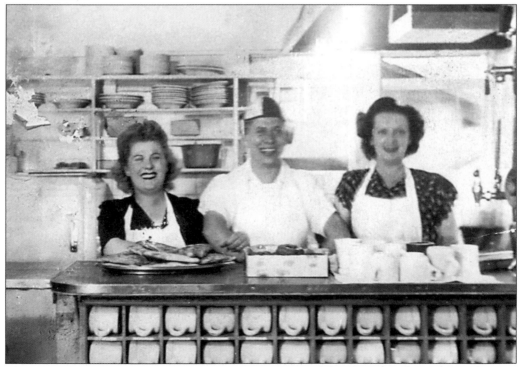

The Wagon restaurant, at 1921 Post Street, was owned by Harry Guthertz (center). Jerry Flamm's sister, Tillie Katz, is on the left. (Courtesy of Jerry Flamm.)

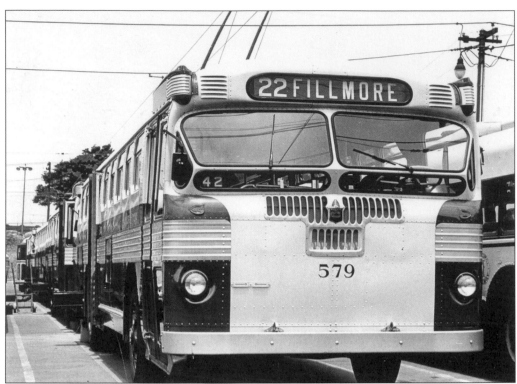

Trolley buses replaced streetcars in 1949. (Courtesy of the San Francisco History Center, San Francisco Public Library.)

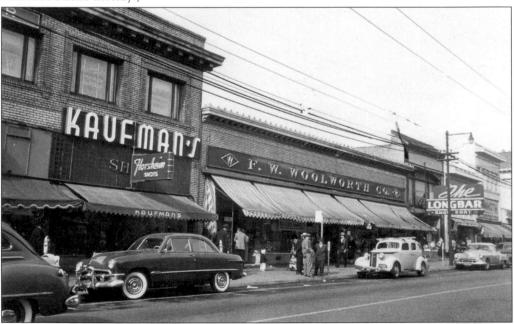

This 1952 photograph shows Kaufman's shoes and Woolworth's, both torn down for the Geary Expressway. The entrance to the Japan Center garage is across the street from the Longbar (now a vacant store). (Courtesy of the San Francisco Redevelopment Agency.)

Six

REDEVELOPMENT

The process of redevelopment was (and still is) controversial, not only in The Fillmore and other San Francisco neighborhoods, but in similar neighborhoods in cities throughout the United States. Soon after World War II, large areas of the Western Addition, including much of the Fillmore, were designated as blighted areas with substandard rat-infested housing, overcrowding, and high crime rates. Backed by federal funds, the board of supervisors in 1948 established the San Francisco Redevelopment Agency to improve living conditions.

In 1956, the first of two redevelopment projects in the Fillmore and Western Addition got underway. While the goals seem worthy, the process of reaching them resulted in the disruption (some would say destruction) of the community, the forced relocation of thousands of people, and the failure of businesses that found themselves without customers.

Most of the people who were relocated were renters, and most were also African American. Despite increasing protests, the process of what some African Americans termed "Negro Removal" moved ahead. Though residents were assured that they would be allowed to return to the renewed neighborhood, it took 10 or 15 years in many cases for new housing to become available. And even at below market rents, they were unaffordable to those who left. Many Japanese, who had begun to return to the neighborhood after World War II, were also forced to leave again.

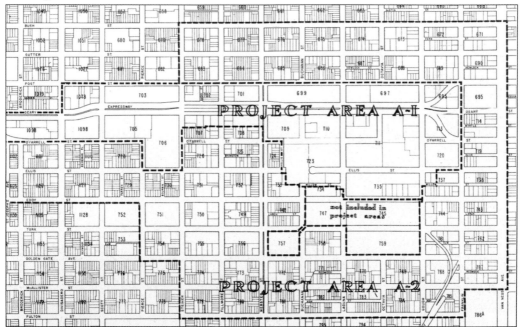

This map shows the two Western Addition projects. Most of the Fillmore is in Area A-2. (Courtesy of the San Francisco Redevelopment Agency.)

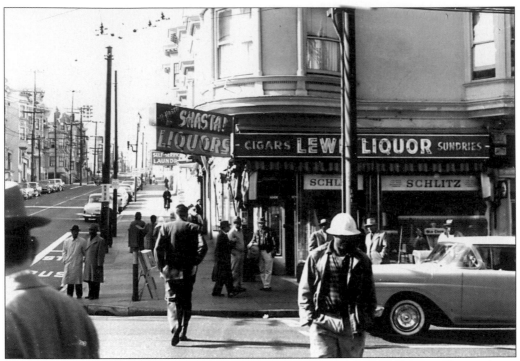

This photo depicts Fillmore and McAllister streets in 1963, before redevelopment began there. (Courtesy of the San Francisco Redevelopment Agency.)

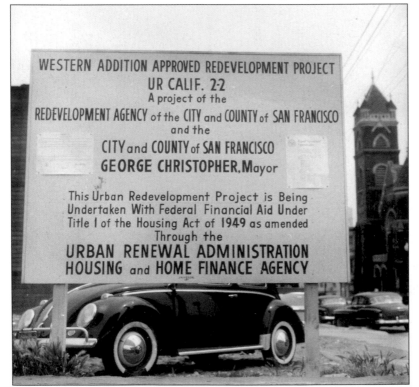

George Christopher was mayor when redevelopment moved into high gear. (Courtesy of the San Francisco Redevelopment Agency.)

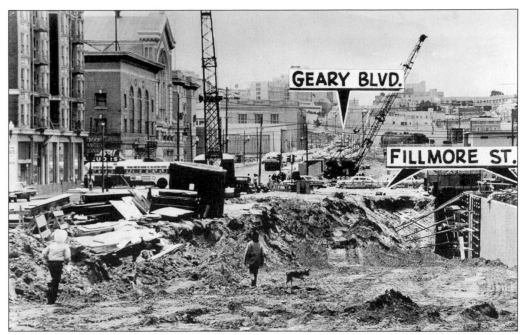

One of the early redevelopment projects was to widen Geary Street into an expressway to improve traffic into the Richmond District. This June 30, 1960 photo shows early construction. (Courtesy of the San Francisco History Center, San Francisco Public Library.)

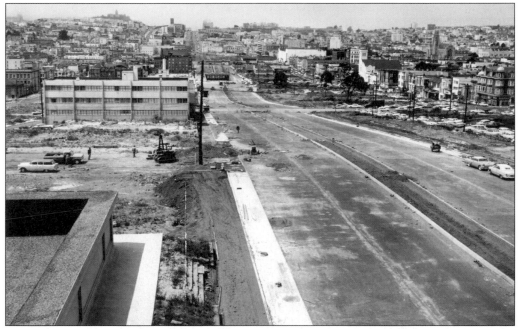

This photo, taken in August 1961 and looking west from Laguna, shows the extent of the buildings that had to be destroyed on each side of the street in order to widen it. The white church just to the right of Geary is Mt. Pilgrim Baptist on Post Street. The large white building farther west on Post is Winterland. Both buildings would be razed in later years. (Courtesy of the San Francisco Redevelopment Agency.)

The Mount Pilgrim Baptist Church on Post between Webster and Fillmore, shown here in October 1954, had a largely African-American congregation. Previously it had been the First Evangelical and Reformed Church, with a largely Japanese congregation. (Courtesy of the California Historical Society, FN-36189.)

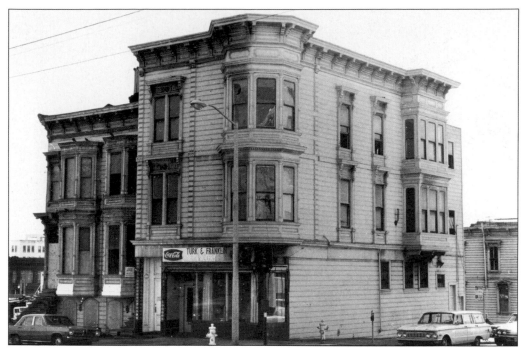

Initial plans to level all buildings in the redevelopment plan were modified after protests led to the relocation of some houses that were considered sufficiently durable to survive the move. This building at 791–795 Turk Street was moved to 1740 Fillmore Street. (Courtesy of the San Francisco Redevelopment Agency.)

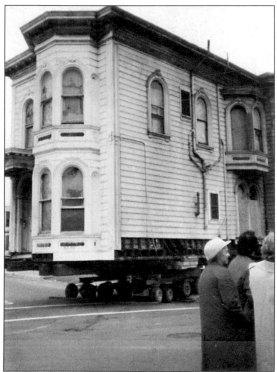

In this photo, a building at 1249–1251 Scott Street is prepared for relocation. (Courtesy of the San Francisco Redevelopment Agency.)

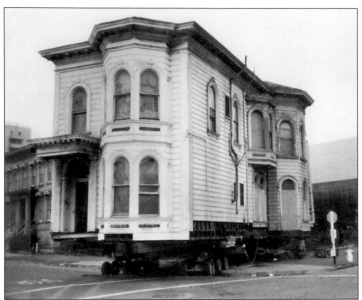

Here is another view of the house at 1249–1251 Scott Street. (Courtesy of the San Francisco Redevelopment Agency.)

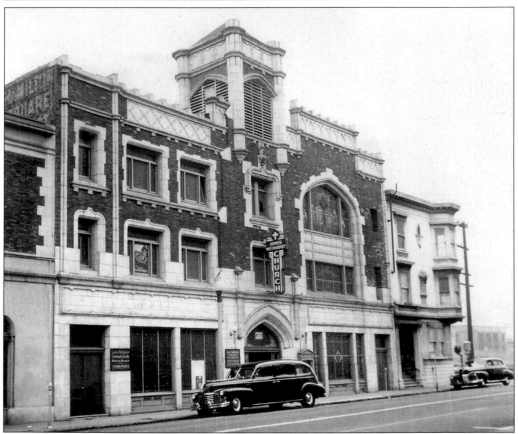

The demolition and replacement of Jones Methodist Church, on the south side of Post at Steiner, was part of the redevelopment project. (Courtesy of the San Francisco Redevelopment Agency.)

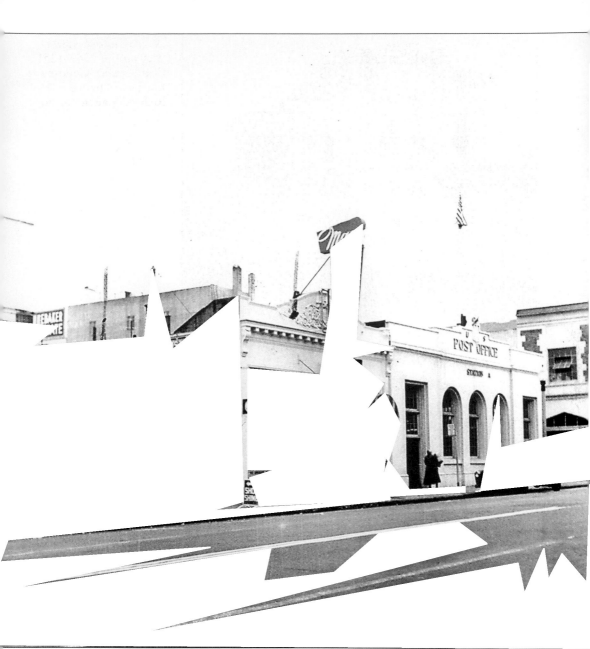

This photograph, taken around 1950, shows Mae Cleaners and the Station A Post Office on Post, between Fillmore and Steiner. The cleaners is still in business, with a different name; the post office is now a hardware store. (Courtesy of the San Francisco Redevelopment Agency.)

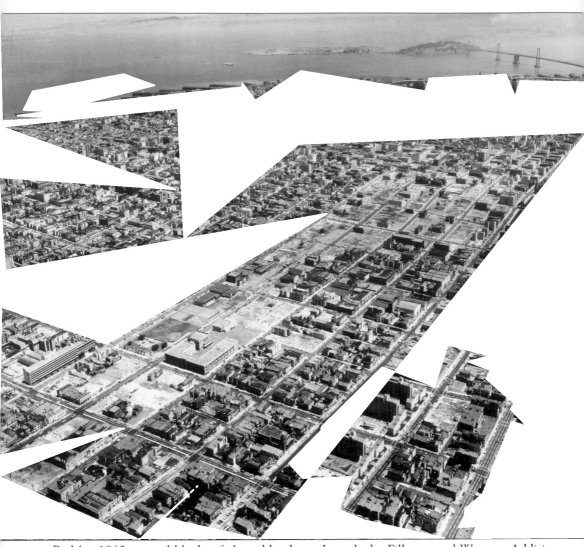

By May 1960, several blocks of cleared land cut through the Fillmore and Western Addition. (Courtesy of the San Francisco Redevelopment Agency.)

This house at 773 Turk Street was moved to 1735 Webster Street. (Courtesy of the San Francisco Redevelopment Agency.)

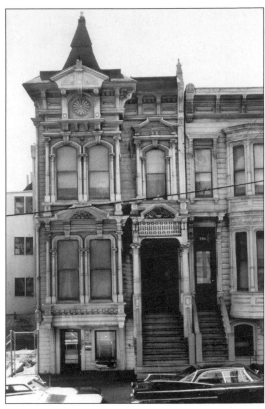

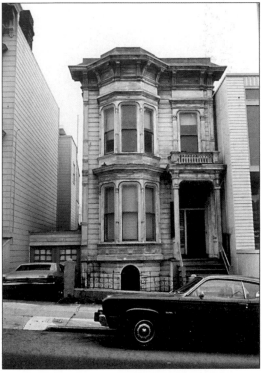

This house at 1759 Sutter Street was built in the 1880s. The three-bedroom, one-and-a-half–bath house was moved in 1978 to 1980 Ellis Street. (Courtesy of the San Francisco Redevelopment Agency.)

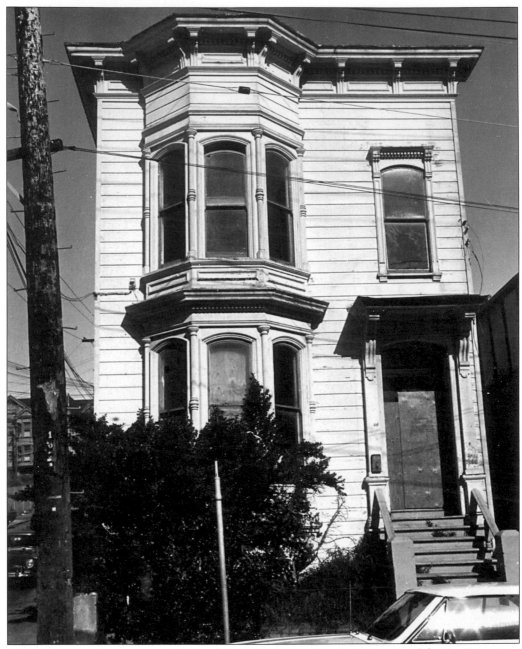

There were no plans to move this house at 1618 Laguna Street. (Courtesy of the San Francisco Redevelopment Agency.)

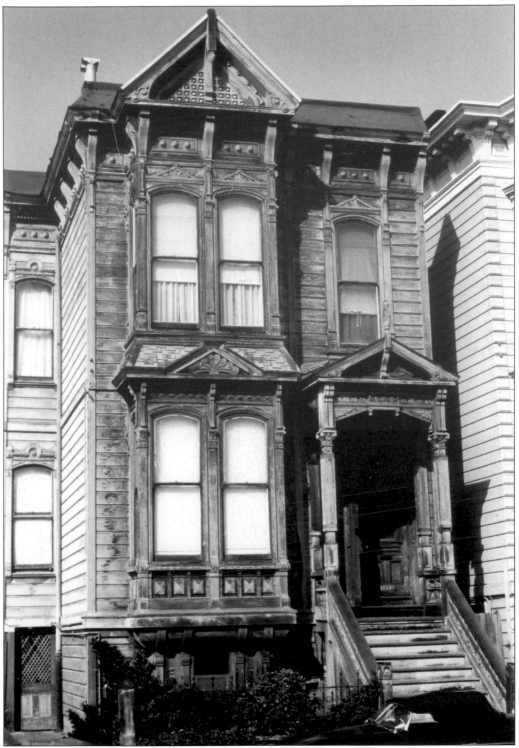

Originally at 1419 Webster Street, this house was moved to 1730 Fillmore. The 1890 Eastlake Victorian contained two flats. (Courtesy of the San Francisco Redevelopment Agency.)

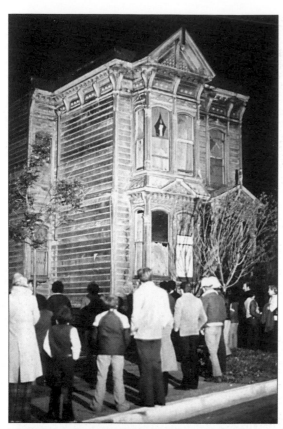

This photo shows the house from the previous photo being moved from Webster to Fillmore Street. (Courtesy of the San Francisco Redevelopment Agency.)

Here is another view of the move. (Courtesy of the San Francisco Redevelopment Agency.)

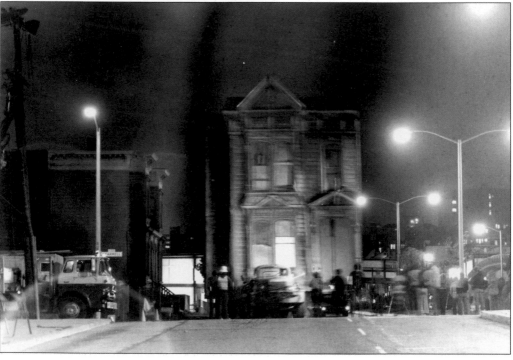

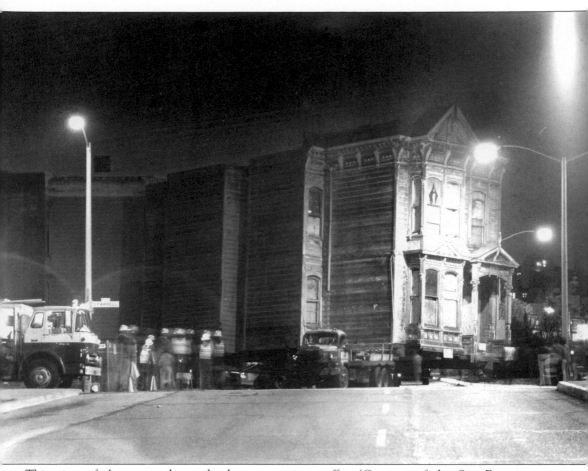

This view of the move shows the house stopping traffic. (Courtesy of the San Francisco Redevelopment Agency.)

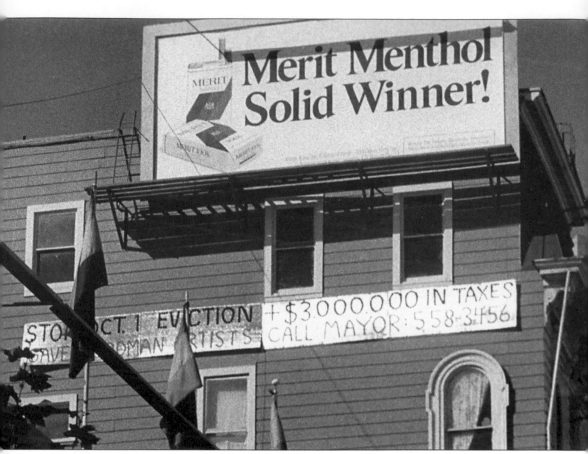

The relocation necessary to continue the redevelopment often led to resistance, as shown in this sign to stop evictions. (Courtesy of the San Francisco Redevelopment Agency.)

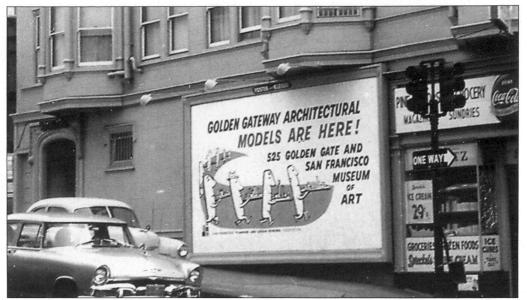

Posters throughout the neighborhood invited people to visit models of new apartments that were planned or under construction. (Courtesy of the San Francisco Redevelopment Agency.)

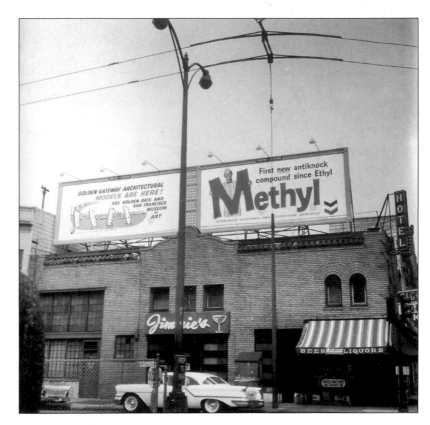

Here a billboard displays the same message. (Courtesy of the San Francisco Redevelopment Agency.)

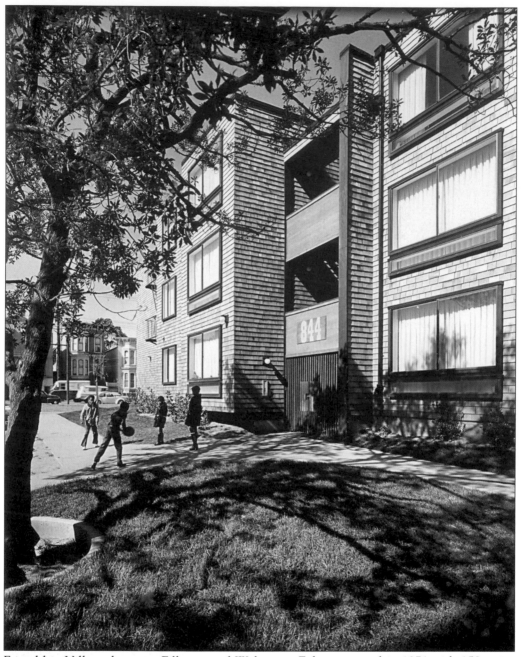

Friendship Village, between Fillmore and Webster at Fulton, opened in 1971 with 158 units.
(Courtesy of the San Francisco Redevelopment Agency.)

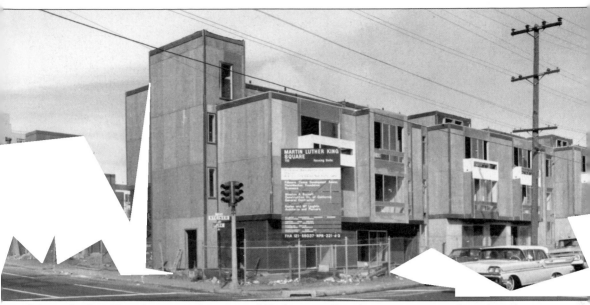

Martin Luther King Square at Steiner and Turk was still under construction when this photo was taken in September 1969. (Courtesy of the San Francisco Redevelopment Agency.)

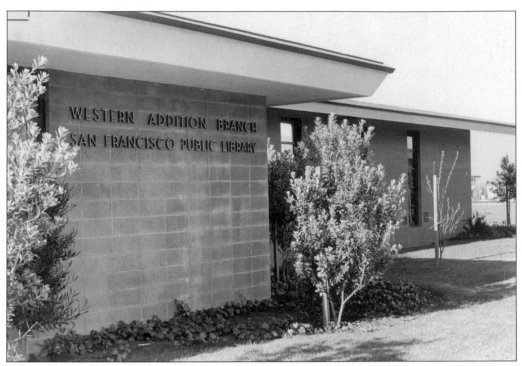

The Western Addition Branch of the San Francisco Public Library opened at Scott and Post. (Courtesy of the San Francisco Redevelopment Agency.)

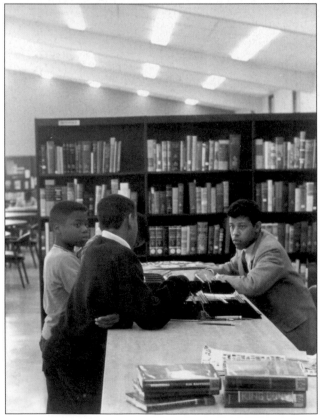

An interior view of the new library is shown in this photo. (Courtesy of the San Francisco Redevelopment Agency.)

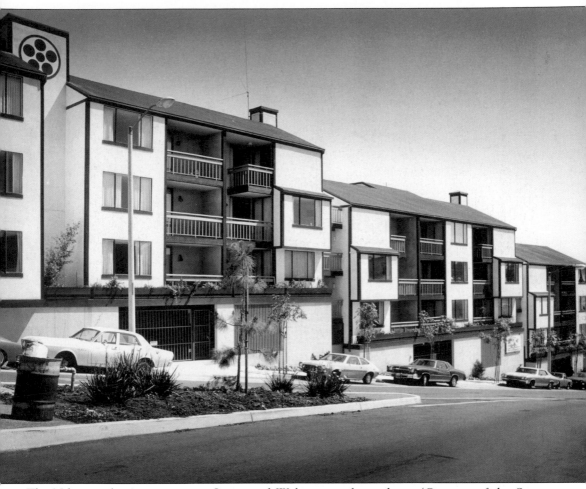

The Nihonmachi Apartments at Sutter and Webster are shown here. (Courtesy of the San Francisco Redevelopment Agency.)

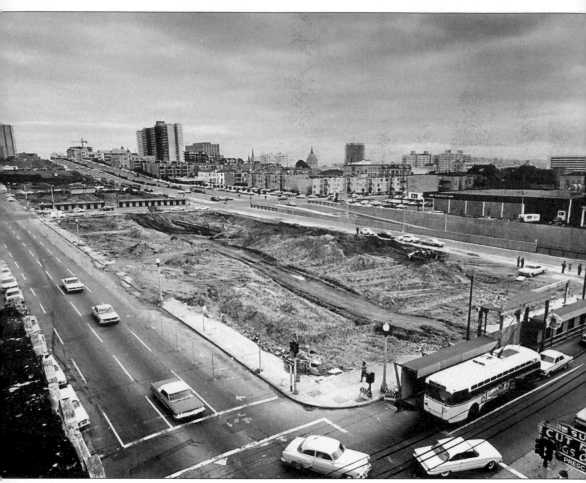

Japan Center, the heart of Nihonmachi, was one of the largest projects in the area. This photo, taken at the end of December 1965 at the corner of Post and Fillmore, shows early stages of construction. (Courtesy of the San Francisco Redevelopment Agency.)

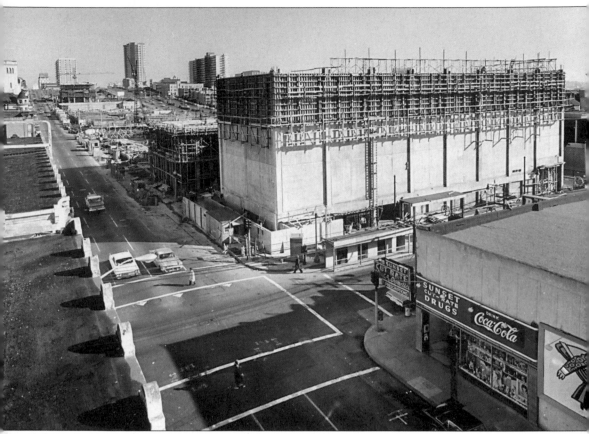

A year later, the view from the same location shows progress, but much work remains. (Courtesy of the San Francisco Redevelopment Agency.)

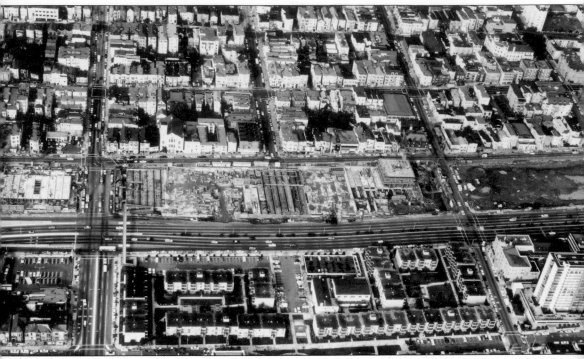

This is an aerial view of the project, with Webster Street (on the left) running through the center of the new Geary Expressway. (Courtesy of the San Francisco Redevelopment Agency.)

Japan Center was just the beginning of redevelopment for Nihonmachi. This 1970 photo of the corner of Laguna and Post, once the center of the Japanese community, shows serious decay. Compare this view with earlier photos of the same intersection, in chapters 4 and 5. (Courtesy of the San Francisco Redevelopment Agency.)

Much work remained south of Geary as well, as this cleared site of the old Acme Brewery demonstrated in 1968. The location is the block bounded by Fulton, Webster, and Grove.

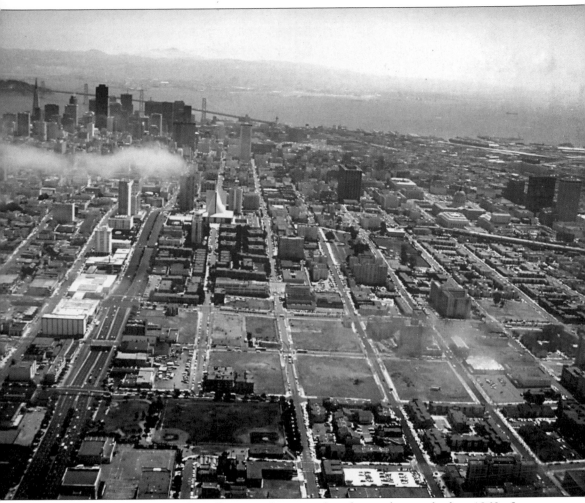

The scope of the project in the Fillmore is shown in this photo taken in the late 1960s. Japan Center, on the left, is finished, as is St. Mary's Cathedral in the distance. But the area from Steiner to Webster, south of Geary, is still mostly barren.

Fillmore Center, in the heart of the old Fillmore, was one of the last major redevelopment projects. (Photo by Robert F. Oaks.)

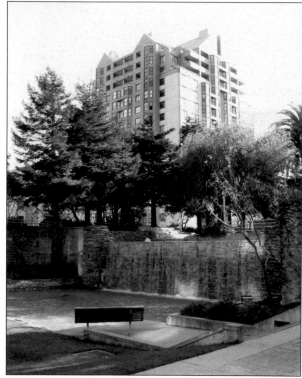

The center consists of nine structures, including three high-rise towers, with over 1,100 low and moderate housing units. (Photo by Robert F. Oaks.)

Seven

THE PAST IS PRESENT

A walk through the Fillmore today reveals the dramatic changes that have occurred due to redevelopment over a period of 40 years. Yet, a more observant walker can still find some links to the past.

The attempt to reestablish the past and bring jazz back to the Fillmore by establishing a "Jazz District" has been met with moderate success so far. The changing musical and entertainment tastes of a new generation make this goal more difficult to achieve.

Suttle Plaza, named for the late Gene E. Suttle Jr., longtime area director for the second San Francisco Redevelopment Agency project (including Nihonmachi and most of the area south of Geary Boulevard), was dedicated in December 2003. The names of 62 Fillmore pioneers and community leaders are inscribed in the plaza. In addition, the Fillmore "Walk of Fame," stretching from McAllister to Post Street, recognizes significant musicians and historic buildings that contributed to the jazz legacy of the neighborhood. (Photo by Robert F. Oaks.)

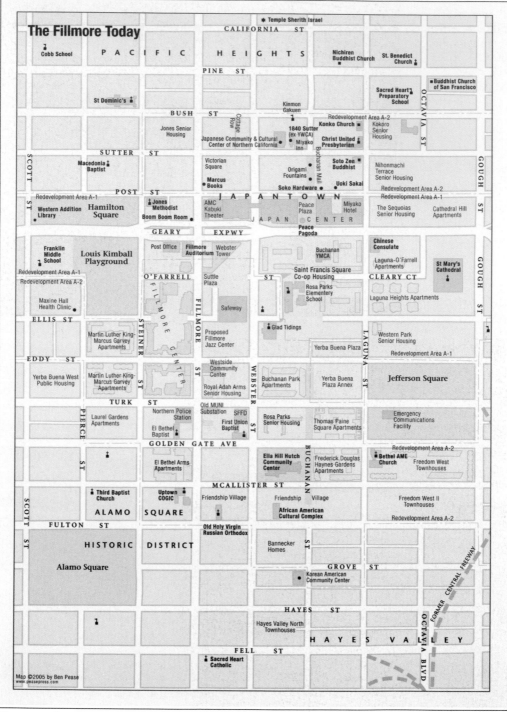

The Filmore Today

Temple Sherith Israel

CALIFORNIA ST

Cobb School

PACIFIC HEIGHTS

Nichiren Buddhist Church St. Benedict Church

PINE ST

St Dominic's

Sacred Heart Preparatory School Buddhist Church of San Francisco

BUSH ST

Kinmon Gakuen

Jones Senior Housing

Cottage Row

Redevelopment Area A-2

Konko Church Kokoro Senior Housing

Japanese Community & Cultural Center of Northern California

1840 Sutter (ex YWCA) Miyako Inn

Christ United Presbyterian

SUTTER ST

Macedonia Baptist

Victorian Square

Soto Zen Buddhist

Nihonmachi Terrace Senior Housing

Marcus Books

Origami Fountains Soko Hardware Uoki Sakai

Redevelopment Area A-2

POST ST

Redevelopment Area A-1

JAPANTOWN

Redevelopment Area A-1

Western Addition Library Hamilton Square

Jones Methodist Boom Boom Room

AMC Kabuki Theater

Peace Plaza Miyako Hotel

The Sequoias Senior Housing Cathedral Hill Apartments

GEARY EXPWY

JAPAN CENTER

Peace Pagoda

Chinese Consulate

Franklin Middle School

Louis Kimball Playground

Post Office Fillmore Auditorium Webster Tower

Buchanan YMCA

Laguna-O'Farrell Apartments St Mary's Cathedral

Redevelopment Area A-1
Redevelopment Area A-2

O'FARRELL

Suttle Plaza

Saint Francis Square Co-op Housing

CLEARY CT

Maxine Hall Health Clinic

Safeway

Rosa Parks Elementary School

Laguna Heights Apartments

ELLIS ST

Proposed Fillmore Jazz Center

Glad Tidings

Western Park Senior Housing

EDDY ST

Martin Luther King-Marcus Garvey Apartments

Westside Community Center

Yerba Buena Plaza

Redevelopment Area A-1

Yerba Buena West Public Housing

Martin Luther King-Marcus Garvey Apartments

Royal Adah Arms Senior Housing

Buchanan Park Apartments

Yerba Buena Plaza Annex

Jefferson Square

TURK ST

Old MUNI Substation

WEBSTER ST

Laurel Gardens Apartments

Northern Police Station SFFD

First Union Baptist

Rosa Parks Senior Housing

Thomas Paine Square Apartments

Emergency Communications Facility

El Bethel Baptist

GOLDEN GATE AVE

Redevelopment Area A-2

El Bethel Arms Apartments

Ella Hill Hutch Community Center

Frederick Douglas Haynes Gardens Apartments

Bethel AME Church Freedom West Townhouses

MCALLISTER ST

BUCHANAN

Third Baptist Church

Uptown COGIC

Friendship Village

Friendship Village

Freedom West II Townhouses

ALAMO SQUARE

African American Cultural Complex

Redevelopment Area A-2

FULTON ST

Old Holy Virgin Russian Orthodox

HISTORIC DISTRICT

Bannecker Homes

GROVE ST

Alamo Square

Korean American Community Center

HAYES ST

Hayes Valley North Townhouses

HAYES VALLEY

FELL ST

Sacred Heart Catholic

FORMER CENTRAL FREEWAY

OCTAVIA BLVD

SCOTT ST

STEINER ST

FILLMORE

FILLMORE CENTER

PIERCE ST

LAGUNA ST

BUCHANAN MALL

OCTAVIA ST

GOUGH ST

This map shows many of the changes resulting from redevelopment.

Posters along Fillmore Street remind strollers of the jazz era. (Photo by Robert F. Oaks.)

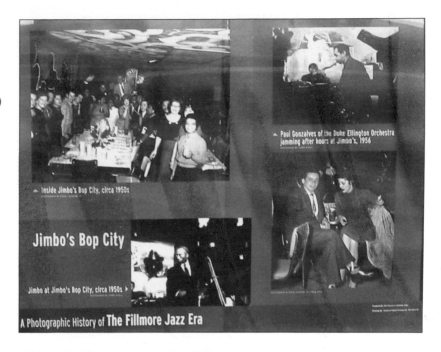

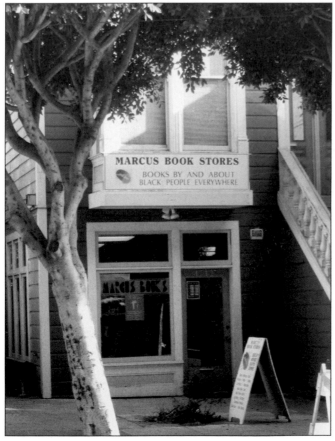

Marcus Books (formerly called Success Book Store) is one of the oldest continuously operating businesses in the area. It currently occupies the relocated building that once was Jimbo's Bop City. (Photo by Robert F. Oaks.)

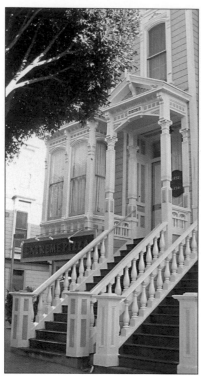

This building at 1730 Fillmore was once on Webster Street. See pages 99–101 for photos of the move. (Photo by Robert F. Oaks.)

This 1876 Victorian at 1740 Fillmore was originally at 791 Turk Street, as seen on page 93. (Photo by Robert F. Oaks.)

Fillmore Auditorium's exterior remains largely unchanged. (Photo by Robert F. Oaks.)

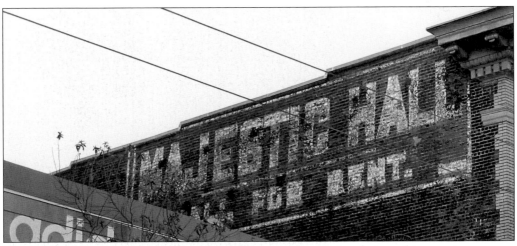

The back of the auditorium, however, displays a fading painted sign of its previous name. (Photo by Robert F. Oaks.)

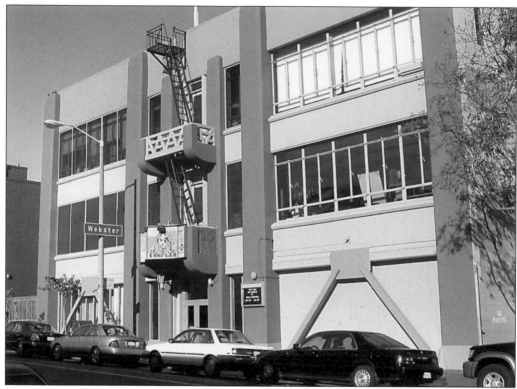

The African American Cultural Center on Fulton Street once housed the offices of Acme Brewery, which occupied the entire block across the street. (Photo by Robert F. Oaks.)

A new post office, next to Fillmore Auditorium, occupies the site of the old Beth Israel Temple, which later became Jim Jones's People's Temple. (Photo by Robert F. Oaks.)

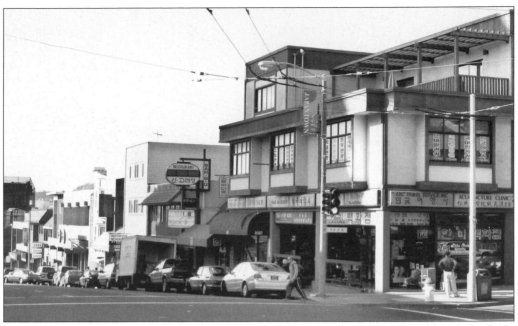

The intersection of Post and Laguna is still in the heart of Nihonmachi, though it bares little resemblance to its former look. (Photo by Robert F. Oaks.)

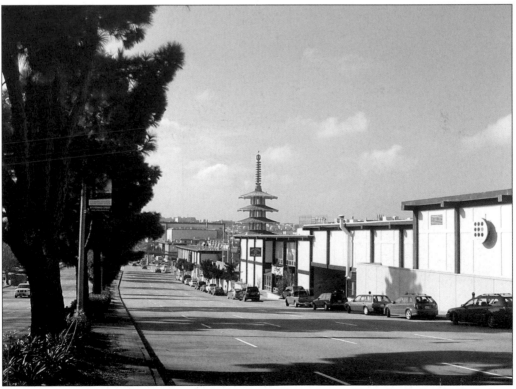

Japan Center occupies the northern side the Geary Expressway. (Photo by Robert F. Oaks.)

This mural, along with several others painted by the artist Aaron Miller for the Emanuel Church of God in Christ on Post Street in 1950, was removed when the church was demolished. (Courtesy of the San Francisco Redevelopment Agency.)

Shown here is another Aaron Miller mural from Emanuel Church of God in Christ on Post Street. These two were preserved and are now installed in the lobby of the Webster Square Office Building at 1426 Fillmore Street. (Courtesy of the San Francisco Redevelopment Agency.)

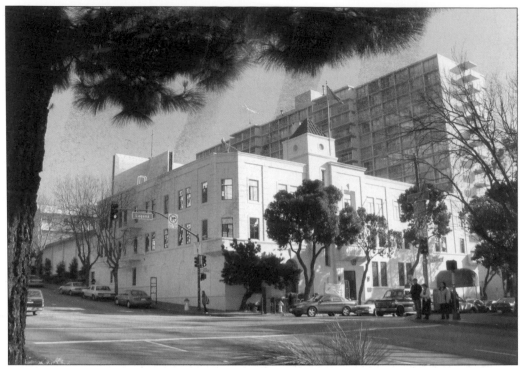

The Chinese Consulate, on the southeast corner of Laguna and Geary, originally served as the headquarters of the Japanese Corps of the Salvation Army. The Salvation Army sold the building to the People's Republic of China in 1974. (Photo by Robert F. Oaks.)

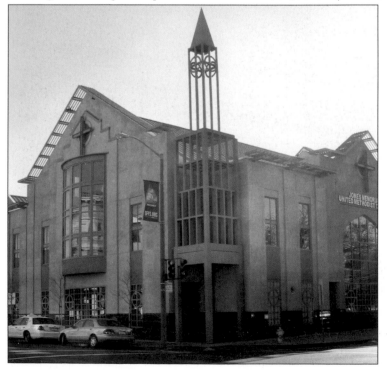

The new Jones United Methodist Church occupies the same location as the old one did at Post and Steiner. (Photo by Robert F. Oaks.)

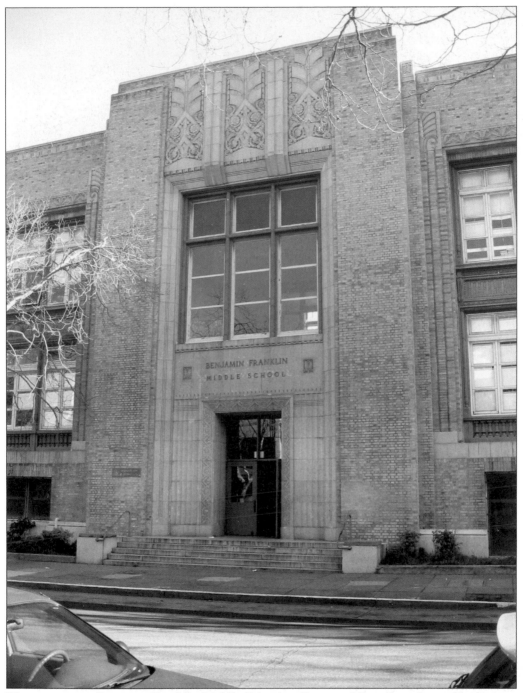

The entrance to Benjamin Franklin Middle School at Geary and Scott has changed little since it was Girls High School. (Photo by Robert F. Oaks.)

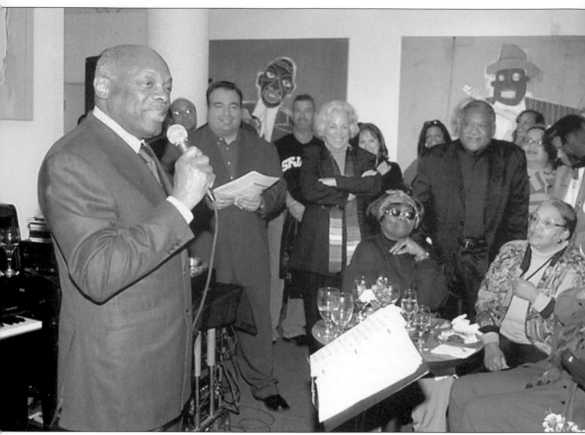

Part of the Redevelopment Agency's neighborhood revitalization was a project to renew the Fillmore's reputation as a jazz center. In this photo, taken in March 2003, San Francisco Mayor Willie Brown participates in opening ceremonies for the Fillmore Jazz District Promotions Office. (Photo by Vic Balbuena Bareng; courtesy of the Fillmore Jazz Preservation District Promotions Office.)

The Promotions Office sponsored free Friday outdoor concerts, such as this one with jazz vocalist Kim Nalley in October 2003. (Photo by Vic Balbuena Bareng; courtesy of the Fillmore Jazz Preservation District Promotions Office.)

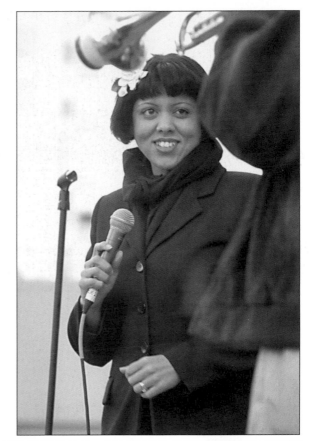

The first annual Big Band Duel & BBQ Cook-off, featured The Fillmore Jazz Preservation Big Band. (Photo by Vic Balbuena Bareng; courtesy of the Fillmore Jazz Preservation District Promotions Office.)

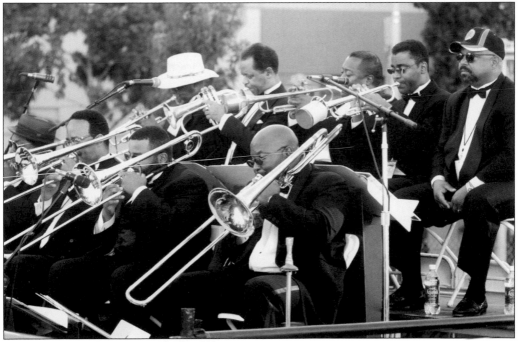

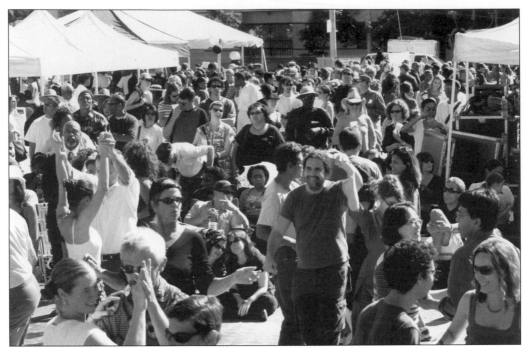

The concerts drew enthusiastic crowds. (Photo by Vic Balbuena Bareng; courtesy of the Fillmore Jazz Preservation District Promotions Office.)

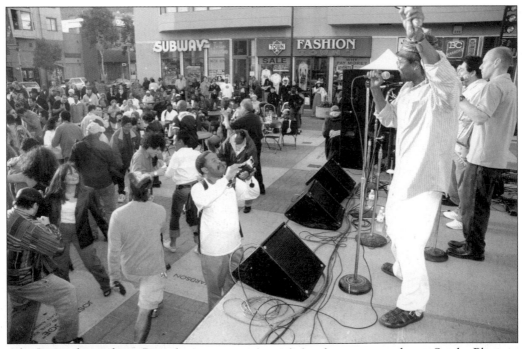

Afro-Latin dance king Ricardo Lemvo performed for dancing crowds in Suttle Plaza in September 2003. (Photo by Vic Balbuena Bareng; courtesy of the Fillmore Jazz Preservation District Promotions Office.)